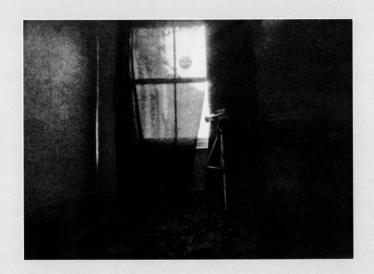

TOPOGRAPHICS

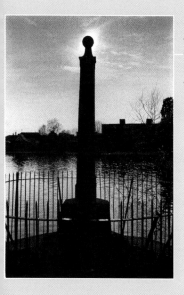

Marc Atkins and Iain Sinclair

Liquid City

REAKTION BOOKS

Published by Reaktion Books Ltd
79 Farringdon Road, London EC1M 3JU, UK
www.reaktionbooks.co.uk

First published 1999

Designed by Philip Lewis

Printed and bound in Italy by
Giunti Industrie Grafiche, Prato

British Library Cataloguing in Publication Data
Atkins, Marc
 Liquid city.
 1. Canals – England – London 2. Canals – England – London –
 Pictorial works 3. London (England) – Description and travel
 4. London (England) – Description and travel – Pictorial works
 I. Title II. Sinclair, Iain
 914.2'1'04859
 ISBN 1 86189 037 0

ACKNOWLEDGEMENTS

Earlier versions of some of these pieces appeared in the following publications:
'A Serious of Photographs' in *The Ebbing of the Kraft* (Equipage, 1997); 'Is This
London?' in *Alive in Parts of This Century: Eric Mottram at 70* (North & South,
1994); 'Sion Ants' in *Subversion in the Street of Shame* (Disobey, 1994); 'Watching the
Watchman' (Jago Gallery, 1997); 'Hungry Ghost' in *Back Garden Poems* (Albion
Village Press, 1970); 'Where the Talent Is' (Penguin Modern Poets 10, 1996);
'Kathy Acker & *The Falconer*' (World Art, 1998); 'Whitechapel/New York' (Winter
New York, 1994). Iain Sinclair would like to thank these editors: Rod Mengham,
Peterjon & Jasmin Skelt, Paul Smith, Keggie Carew, Ashley Crawford and Anet
van de Elzen.

Marc Atkins wishes to thank Françoise Lacroix, Michelle Lacroix, Natasha Lythgoe
and Lil. The images on pages 111, 113, 116 and 117 are from Atkins's video 'Through
the Corner of an Eye' (1998).

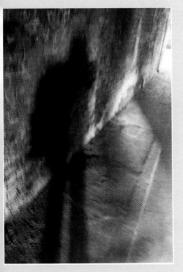

I followed him; who, shadowlike and frail,
Unswervingly though slowly onward went,
 Regardless, wrapt in thought as in a veil:
Thus step for step with lonely sounding feet
We travelled many a long dim silent street.

JAMES THOMSON, *The City of Dreadful Night*

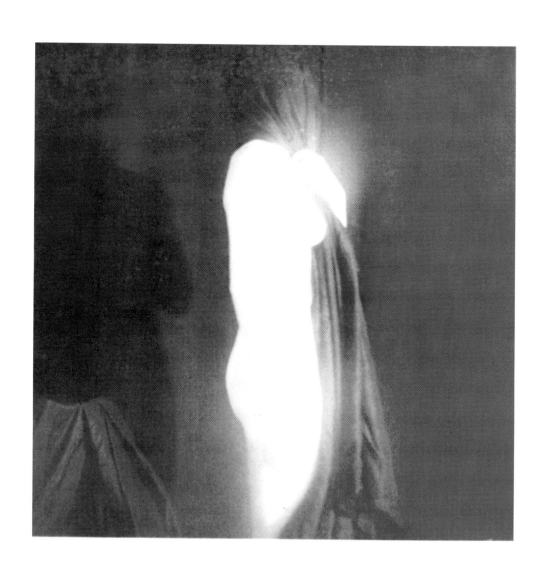

Elective anonymity

All I can do is suggest scenarios.
MARC ATKINS

Marc Atkins lives in X, sharing his life with Y (and Z and P, Q, R, S). He bases his philosophy and work practice on a thorough knowledge of O. 'What I want,' he told me, are '****** of *******.' What he also wants is to exist in his art. Nothing else. He pleads the Fifth Amendment. It goes without saying that he is not, and never was, 'Marc Atkins'. There's no birth certificate. No biography beyond the ever-swelling cv of small shows, author snaps, book jackets; the record of educational establishments, art colleges at the end of their tether, overseas gigs that provide the lucky recipient with just enough breathing-space to fill in the application for the next residency, the next temporary studio. It's not a fashionable position in the days of Me-Art and the corporate scream, but what Marc's after is a mystique achieved by the study of whatever lies within the perimeter of the print. What you see is what you get. An unimplicated image.

So that is the argument between us when we share a day's walk. Such autobiography as I want to deliver comes through portraiture, exaggeration, caricature. The city as a darker self, a theatre of possibilities in which I can audition lives that never happened. The Atkins figure who cheerfully busks his way through my book *Lights Out for the Territory* is a fictional construct. An analogue of what he ought to be – if I were a small mad god laying out my own multiverse.

When I ask Atkins, on one of our London journeys, to shoot a building, a figure on Vauxhall Bridge, the fantastic Tradescant tomb, rainwater on a skull-and-crossbones monument, the vegetative head of Bunyan in Bunhill Fields, he will, ever the professional, try to give me a print that is as 'clean and crisp' as he can make it. But then, in the alchemy of the darkroom, he subverts this impersonal neutrality. He will 'print the darkness' and 'give it a stronger, more disquieting element'. Disquiet was always his benchmark – unease. He looks for articulate shadows. If an image is too complacent, if it fails to disturb, it will be put aside; worked over, scratched, printed on heavier paper,

until it justifies its place in the archive. The tension between writer and photographer derives from complementary instincts working in different directions. Atkins interrogates a random documentary impulse until it archives a pre-fictional state of flux: agitated light, ambiguity, significance. I try to mould wriggling chaos, like a fistful of jelly, into some credible form. He waits, waits, waits. Then, finding his moment, he blazes off three or four rolls of film in less than half an hour. And comes home with something that resembles a catalogue of expressionist topography. I let it all pour through, hoping to find some way to erase the tape, burn off the inessentials: locate the single, pre-existent and eternal mark on the wall.

Comparing the plunder that we brought back from these walks – Marc's contact sheets, my jottings and colour snapshots – it was clear that our approaches could barely be reconciled. What we would have to solicit was the third element: that which was unknown, unpredictable. Something I couldn't describe and he couldn't photograph. I worshipped light: early morning in Arnold Circus, a tired sun going down behind the sugar factory in Silvertown. I thrived on movement, drift, being out in the weather. I wanted a single sentence to contain everything I knew. I suffered (exposure to Jack Kerouac at an impressionable age) from that impulse to sketch, note, improvise, revise, double back, bifurcate, split like an amoeba. My rampant schizophrenia expressed itself in the act of transcribing the speech of dogs, watching cloud-streets advance across the mouth of the Medway, listening to the shapeless buzz of cafés, trains, supermarkets – until I arrived at that nanosecond when the pattern was revealed, before it vanished forever.

Atkins employed a furious intensity, a level of concentration that left his thin, stubbled skull ringing like a Whitechapel bell. He was stiffnecked (lacking bolt), at the mercy of cumulative migraines. He worried at his prints. He rubbed the darkness until the first faint traces of meaning appeared. 'I form a virtual bubble around whatever I'm photographing,' he said. 'I *see* the picture. I think in terms of "recognition of shadows". I wait to recognize what I want, what I know is there. My prints are three-dimensional sculptures.'

Domed crystal in hand, eyeball magnified, Atkins would race along the frames of his contact sheet searching out something that *might* unsettle him, provoke the necessary excitement. If he had

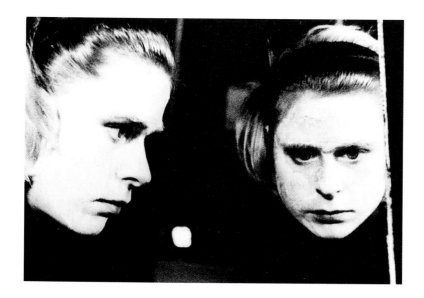

achieved exactly what he set out to do, he would reject the image. It would never become a print. He wanted a shape from which he could extract a measure of darkness. Controlled recklessness: the closed room, the sealed set, the bite of chemicals. Forcibly exposed to the climate of London, he shifts exterior to interior: broken statuary in a wilderness graveyard is revealed as stone furniture, skies are liquid ceilings becoming rivers of swift light. Pores of cracked plaster in an abandoned house breathe and sweat like tired skin. Grass is hair. Split paving-stones become lines of uninterpretable text.

I look back on my own instant-print snapshots taken on our walks, and I see countless impressions of Atkins as a manic ecto-morph in shorts and T-shirt, in tortured poses on stumps of wood, lying in the dirt, head twisted, martyred by the agony of procuring a perfect representation of chaos. A rectangle, or view, that deserves to be cut out of historic time, liberated from narrative excess. Place doesn't matter to Atkins (so long as he's kept off the river, out of the Rotherhithe Tunnel). Whatever I told him – cod histories, bent myths, inauthentic rumours – he subverted. His prints had their own austere poetic. By excluding inessentials, he allowed fiction to creep in at the back door.

'Even when I'm out in the sunshine,' Atkins told me, 'I start, in my imagination, from a dark space. I know I can lose the other bits

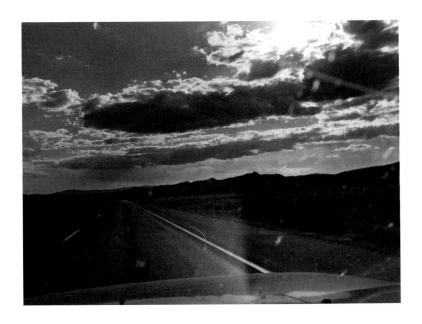

in the darkroom.' He thinks of travel, the life of the road, London topography, as 'sister experiences' to his primary work: the modelling of the figure (usually naked) in a curtained room. He admires Robert Frank, but doesn't have that tender human curiosity, the rhetoric of gesture that makes *The Americans* a graphic novel of immigration and transience. Sunlight, space and movement present real difficulties for Atkins. 'When I drove across America,' he confessed,

> I found that I was driving for a day, then stopping in a motel. It was always hallucinogenic – what I was seeing when I looked up at the ceiling in the motel room. There's no shadow when you go across the desert. You see mountains. The light hits them flat on. You look across the plain: no shadows. It's all light. I felt that I was cutting through the image at a tangent, rather than layering it in front of me. It was as if I was cutting through a series of flat screens. The road was cutting the image in my head. I was snatching at it. I looked at TV sets in the rooms, the carpet, the furniture, as the only way of *shutting the mind off*. I had to find a way back to a state of disquiet.

Struggling with these difficulties for so many years has left Atkins with a monumental archive of prints: a displaced autobiography,

portraits of vanished writers, demolished buildings, unique epipha-
nies of light that can be re-imagined but never experienced for the
first time. You can't rebuild London from this formidable catalogue,
but you are free to work your own combinations. You can conjure
up the grid-patterns of a shining city from these loud particulars.
Statues migrate. Churches float. Iron bulls trumpet from the roofs
of mock-Byzantine temples. But Atkins, as curator of this dreadful
library of memory, suffers. 'I would love,' he told me,

> somebody to come and take them away. It's such a weight. At least
> once a year I want to take them into a field and burn them. Release
> myself. It's like carrying a great yoke around. I want to get rid of
> it. I'd like to see all the people in the photographs warming their
> hands on their burning images. But, just as I'm about to strike the
> match, I stop myself. For whatever reason, it seems to be important
> to hold on to these things.

Even if this pyrotechnic scenario were enacted – like the book
dealer Driffield roasting his unsold stock on the Isle of Sheppey –
Atkins would be obliged to take a photograph of *that* ceremony. The
flaming print would become the first item in a new collection. Then
there would be the dawn shots on the drive out of London, the transit
across the mysterious Isle of Grain. I'm afraid there's no end to it
now. No life for the man beyond this compulsion, this sickness: his
art. No past that can't be retrieved from a sliding drawer: 'I go back
and look at images that have been in a box for ten years, all the other
images that are still around, and they've *changed*. They are the same
image that I put away, but now I understand them. I understand who
I was.' It is our job, as predators who exploit the photographer's skill,
to come up with the fictions, essays, improvisations that will grant
darkness a history and draw it, tentatively, towards the light.

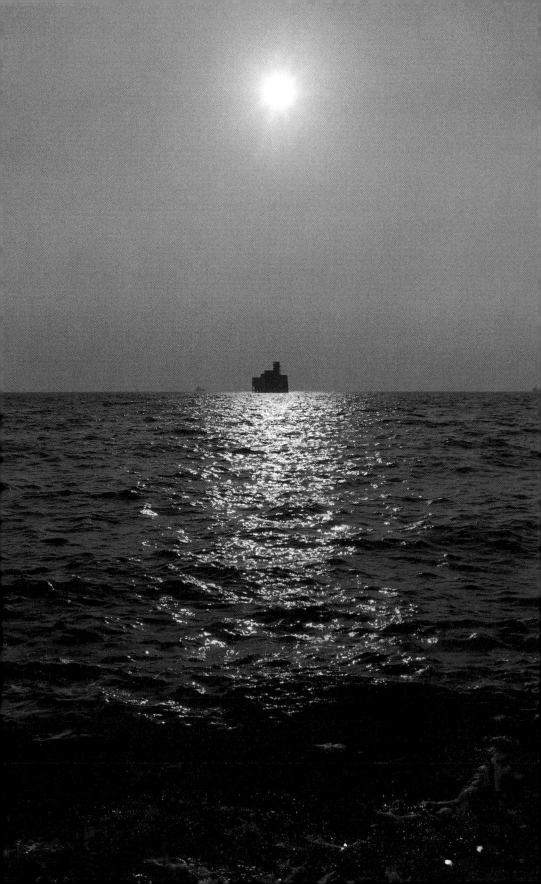

Walking the tidal Thames

Walks undertaken as research (trips to the Isles of Sheppey and Grain as test runs for *Radon Daughters*). Motorized excursions to back up that research, out-takes from a film (*The Falconer*). Visions of the Grain Tower across wet sand, ferries out of Sheerness creeping along the horizon. The overgrown car park of the power station. Locations so obvious it was embarrassing to shoot them. The film-essayist Chris Petit and a shivering Ian Penman in a cavernous pub at the edge of the caravan colony staring in disbelief at what is offered as food. Marc Atkins: sometimes there, sometimes not. Reaching into his black canvas satchel. Old Leicas, cameras held together with sticking plaster, borrowed cameras, gifts; new rigs emitting sinister clicks to punctuate the inaction.

Walks for their own sake, furiously enacted but lacking agenda. Strategic walks (around the M25, the walls of the City) as a method of interrogating fellow pilgrims. Walks as portraits. Walks as prophecy. Walks as rage. Walks as seduction. Walks for the purpose of working out the plot (from Albion Drive, by canal and river, to Springfield Park: coffee and bacon roll). Walks that release delirious chemicals in the brain as they link random sites (discrete images in an improvised poem). Savagely mute walks that provoke language.

Atkins and I undertook a number of one-off jaunts that carried us along the length of the tidal Thames: from the Isle of Grain to Teddington. And on into territory in which we had no business. Breaking off at Shepperton, in homage to J. G. Ballard.

There was no ulterior motive, no commissioned or projected work to justify these riparian exercises. Days in the air. An early breakfast, a pub lunch. Odd esturine landscapes previously glimpsed during river trips. Gull islands. Sewage farms. Oil refineries where Count Dracula's abbey once stood. My jottings in the red notebook could be glossed as poems that failed the audition. Misdirections. Shadows infecting a shoreline that resisted metaphor.

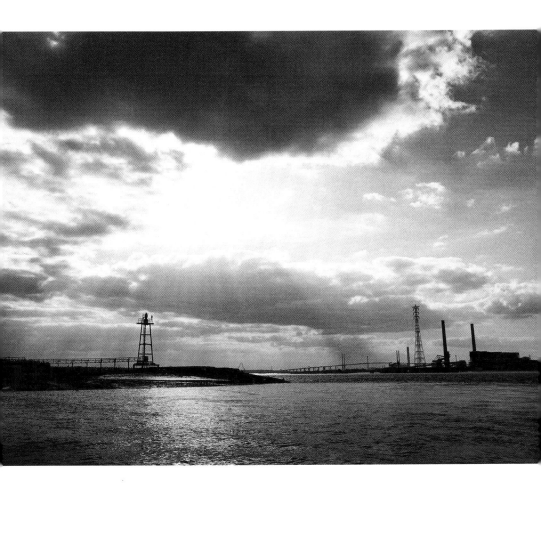

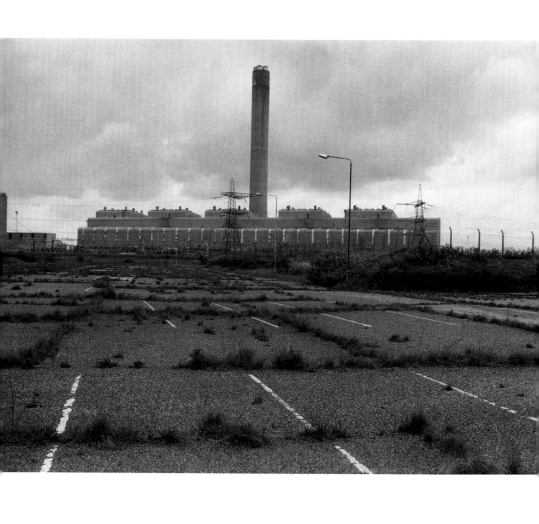

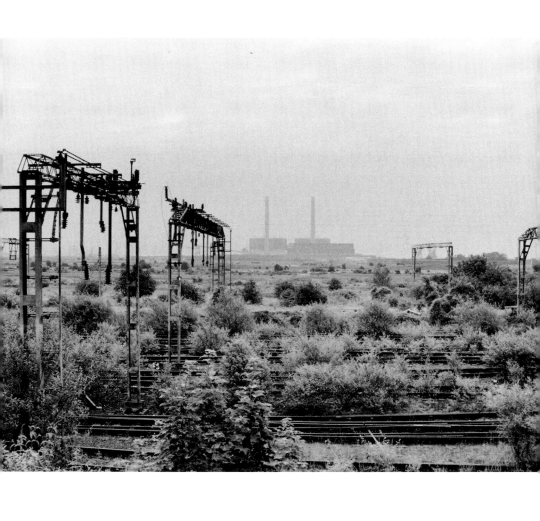

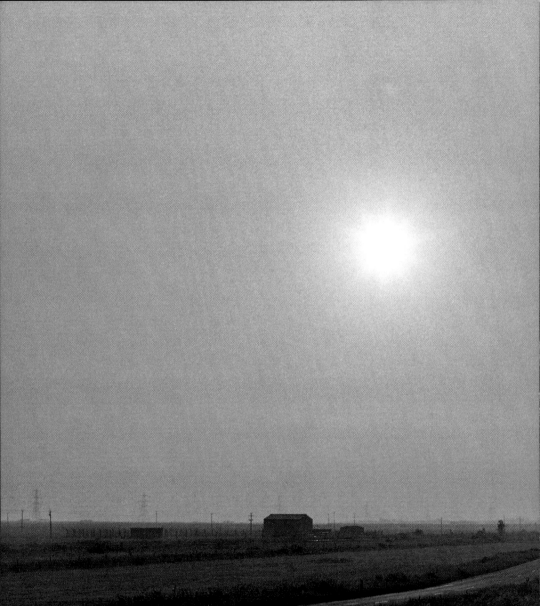

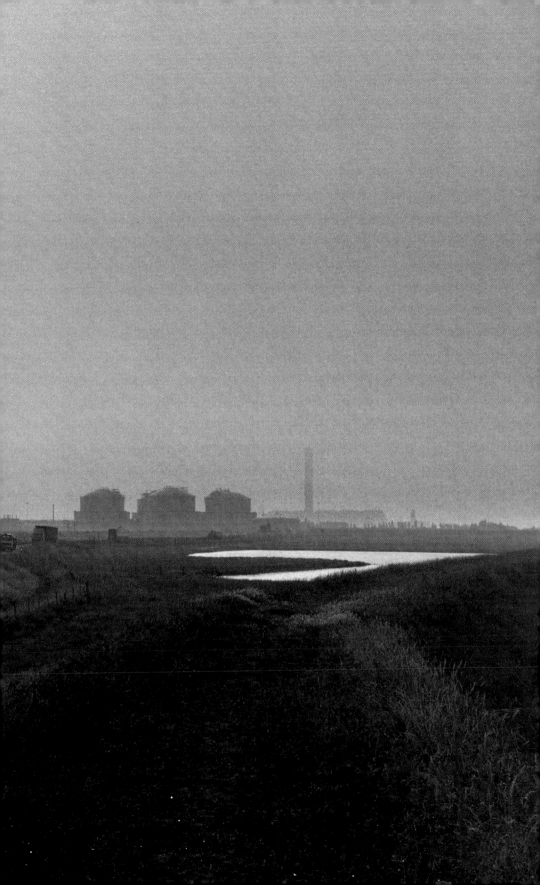

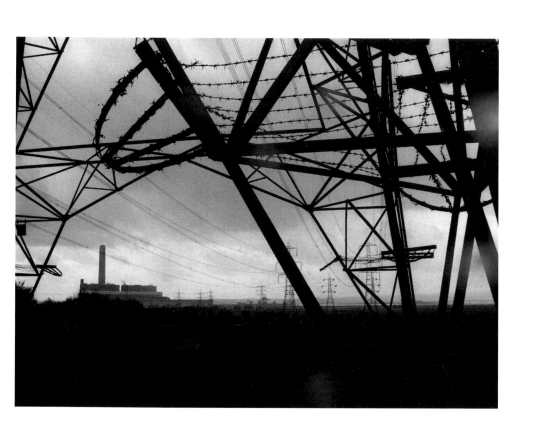

A serious of photographs

(Stepping out from the Isle of Grain)

i

hard on the heels of hope, westward
unhyped, either bank 'could turn into
something or other', one pilgrim thinks
while his companion
is not recorded, no paddocks, a sense
of husbanded disease, soul fatigue, excess
vegetables, say it, red beans
clouds of body gas to drop the midges, open
land in a shower of underexploited air
always to our right the broad
& grumbling river

ii

among the volume radiators, pale
spines a library of dry & whistling pipes
bug overcoats – on foot you still
haunt urban attics – noise is kinder
(in the German sense) cannily
transported, hot clay ridges, a bird drops
on a weak branch, holds its weight
waits, as we are too sudden & greedy
sighs, more shove less drive
out back along the mud-crack'd shoreline
the same rubber-solution tide, bulk containers
peddling pansy tubs on planks of shit

iii

we've trafficked too much in obscenery, punned
the archetypal Atkins, 60 years too late
for David Jones, hefting a tired vest to let his
snake tattoo taste the oily air, I don't
for example consider poets are rock 'n' roll
old or new he said apologetically quite the reverse
(another case to drop from the carousel)
duty declared & all charms to ward off
the fear of flying fit nicely in a designer
carrier bag (later a bank-mask & sex aid)
(later still a shield against nuclear sunburn)
so can you tell me the unident sneered
the nature of your business at the fibre-optic
satellite of Gravesend (top marks to the
wall of early ripen'd figs), no answer as our
elevated cage swings free over the white
bowl the sepulchral stone of Dr Field

Kent 'rolling' eternally away. England
he gasped. let's come back with a camera
as if we could, no chance of a tea-break
in Tel's roadside shack, the anachronistic
pick-up of the watertower, no trout
left in the pool. a lunch-hour barmaid's
wren-brown neck is silently remarked,
high breasts, narrow waist, all that
artifice can add to nature. ex-nautical
geezers in starched T-shirts & gold chains
out in the corn, scarlet poppy fields
under the pylon-cradle where tide surges
around a fixed post (Deptford Bridge) &
the noise of the dead is everywhere unheard

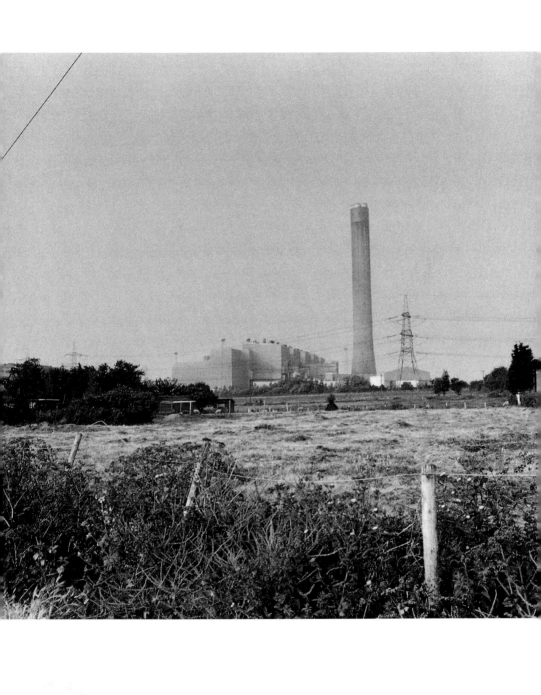

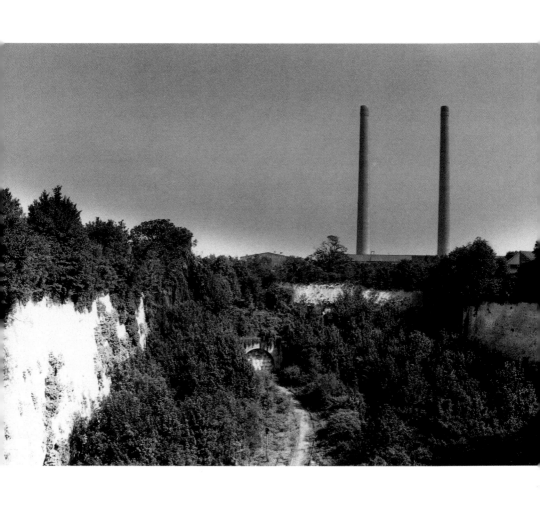

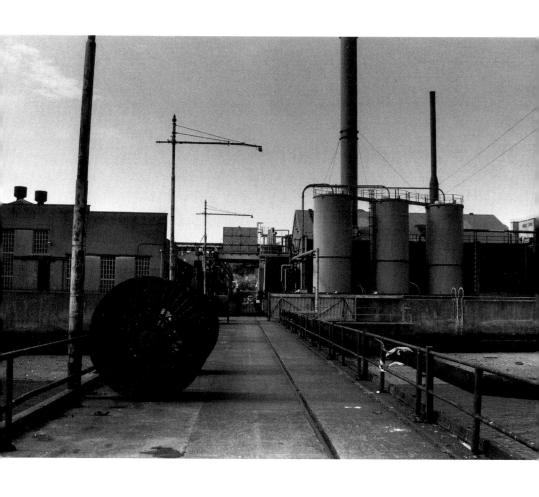

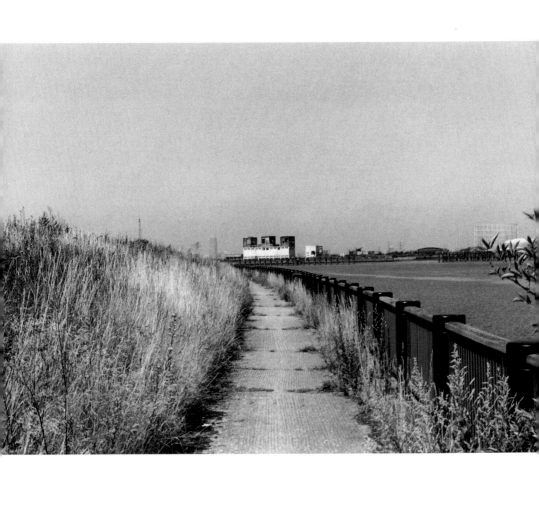

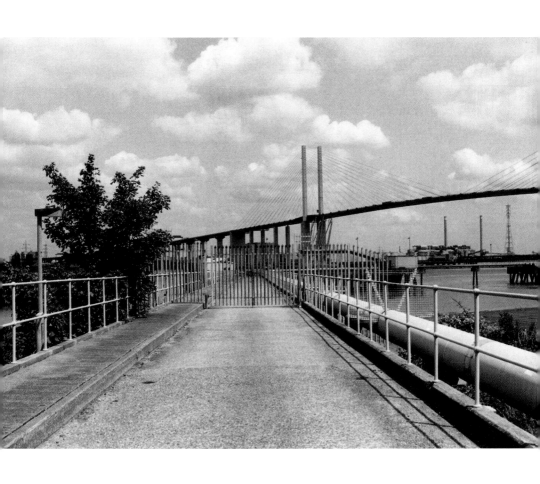

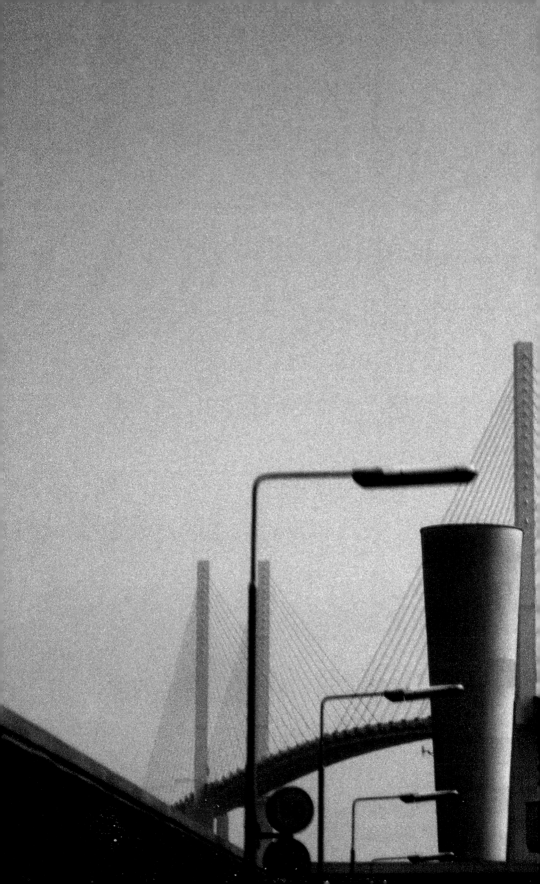

Is this London?

7:00 a.m.: 20 June 1994. Rendezvous with Marc Atkins at the junction of Queensbridge and Hackney roads. Toshed furniture with its caramel gloss not yet blocking the pavement. As we walk (towards the cashpoint), I try to explain who and what Eric Mottram is. Oral history in its most debased form. Misinformation, hideously abridged narratives. I work my way through the honours board of those who have, over the years, made the pilgrimage to Herne Hill. For tea and sugar buns. Free-floating seminars. Eric dozing off in front of a gash video that he will later review with trenchant enthusiasm. The names don't mean anything to Atkins. This is deleted history – Allen Fisher, Bill Griffiths, Barry MacSweeney, the heroes of the 'British Poetry Revival' – have been expunged from the record. Poetry is back where it belongs: in exile. In the provinces, the bunkers of academe. In madhouses, clinics and fragile sinecures. It's lucky that we have a five-hour walk ahead of us. Time enough to exorcise my bile.

Marc's project is to photograph back-catalogue writers. The vanished who don't yet know it. Prints he will one day flog to the National Portrait Gallery as the record of an unpublic generation. The last scribblers without agents and percentage-grubbing publicists. My ambition is simpler: to find some excuse to wander London. Vagrancy with a slate roof over its head and the price of an egg roll jangling in the pockets. Self-sponsored destitution. Petrol money detoured into a second pair of trainers and socks that guarantee freedom from blisters.

We open with a familiar canalside ramble to the Limehouse basin. The scoured hulk of Hawksmoor's St Anne (her sooty accretions steamed away) has been restored to anonymity: a Masonic resource for apron-wearers who have long since decamped. Marc gets to work on the pyramid and tower. In spite of the wide-angle lens, he has to lie on his back to squeeze in all the (un)necessary visual information. A freak show of twisted limbs and Marcel Marceau posturing. There's

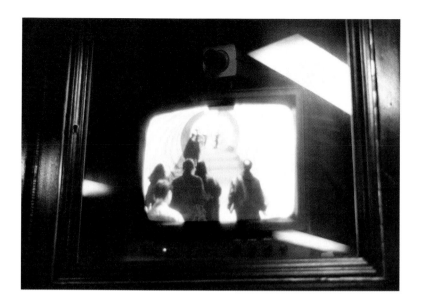

an old gent, whiskered, in one of the window-alcoves. Marc reckons it's an avatar of Mike Moorcock, returned to his London dreaming. Moorcock as an unemployed Father Christmas, putting in time until they open the grotto at Gamages.

As we grind, yet again, through the glazed reservation of the Isle of Dogs, Marc begins to hallucinate women. A bad sign, so early in the day. He's yarning compulsively, and his stories always begin the same way: 'I was walking through Vienna / Rome / East Chicago / Aberystwyth with this woman when . . .' I tell *him* how Professor Mottram accumulated his extraordinary archive of poet-voices (the legions of the unheard), recordings of every significant writer who'd ever picked his nose in London. Interviews. Interrogations of the dead. Epic recitals of texts that didn't aspire to the vulgarity of publication.

Llamas are grazing on Mudchute in the demesne of Canary Wharf. Spectral orchards around the fringe, fringing the ditches. White blossom on black skeletons. Marc doesn't like the look of the cows. Nor they him; the shapes are not complementary. They don't belong in the same landscape: the verticality of Atkins (who is always searching for pediments on which to place himself, empty niches in which to play statues) and the udder-heavy terrestrialism of the curious beasts.

(I never walked further with Mottram than the distance from lectern to cafeteria. Front door to armchair. Our early conversations were all in coffee queues. 'At least you can distinguish what the words are,' he said to me, after my first appearance at a conference he'd master-minded. Even if, as he implied, they didn't carry much weight.)

There's an admirable closed-circuit TV monitor in the lift at Island Gardens. Vast. It confirms my impression of the liftman (usually black) as Charon, ferrying the dead between the levels of the city. One moment out in the sunshine, staring across at the prospect of Greenwich, the observatory on the hill, and the next, monochrome. A pearly screen. Shadowdrift. Heads that flare like sulphur-sticks. I could stay here all day, watching the ghosts in the tunnel. They have to cross the river under their own momentum. Down the ramp, into the tile bore. It's unnatural. Nobody charges you anything. No pay-per-view. The lift is roomy and well appointed. And you don't have to eat limp cheese tartlets from a doll's tray or suck lukewarm coffee from a plastic thimble.

On the other shore, reborn, breakfasted, we bound like lambs down Shooter's Hill. We're pushing it now, there's still plenty of ground to cover and most of it is unknown. We'll need to stop, poke about, investigate the odd pub or bone-pit. I'm in mid-stride, mid-monologue, when a deranged man (French) grabs me by the sleeve. The Frenchness is not the source of his derangement. There's some-thing wrong with the landscape. Nothing fits. His compass has gone haywire. 'Is this London?' he demands, very politely. Up close, he's excited rather than mad. Not a runaway. It's just that he's been working a route through undifferentiated suburbs for hours, without reward. None of the landmarks – Tower Bridge, the Tower of London, Harrod's, the Virgin megastore – that would confirm, or justify, his sense of the metropolis.

But his question is a brute. 'Is this London?' Not in my book. London is whatever can be reached in a one-hour walk. The rest is fictional. We feel like dragging this Frenchman off the street to dis-cuss and debate the monster problem he has set us. What would the professor say? Mottram always sprayed out footnotes that threatened to overwhelm his narrative. But this wasn't his turf either. It was a road to be endured, running back towards whatever we were escaping. Eric survived by ballasting his home with stacks of literature, records,

tapes, files, letters, pamphlets exchanged with the great and the obscure: resources, prompts, snapshots. A memory-umbrella beneath which he could withdraw, murmuring about the dark forces that were overtaking his arcadian retreat.

'Four miles,' I reply. At a venture. 'London.' A reckless improvisation. 'Straight on. Keep going. Find a bridge and cross it.' I talk as if I'm translating myself out of a language primer.

Funeral streets with nothing to watch. Discreet settlements folding back from the hill-ridges. We don't have the time to do justice to Nunhead. Grave-names erased in dense undergrowth, multiple paths leading into tangled thickets. A quilted silence. Coming here is a rehearsal. Marc says that he would love to take Eric's portrait against some clump of broken statuary. There's a retrospective quality to the light. It's infected by tolerated greenery, damp stone. He's never met the man, but the journey, the miles we have walked, inform whatever it is that he will finally capture. The slog through Eric's long and busily inhabited life: a child of the suburbs (it's always disturbed me, the sonar echoes of Kingsley Amis in Mottram), wartime convoys to Archangel, Cambridge, culture-binges through Italy, committee meetings, lectures, concerts, composition and publication. The enthusiasm that drove him; stress-lines had to show. Barks of derision, snuffles, detonations of laughter. An over-burdened head nodding out in a dim reading as yet another poet drones through his interminable hour.

In an ellipse, we sweep through Peckham Rye. A swift impression of parks, green spaces, pleasant houses. Angel trees have been discontinued. Dulwich is loud with all the silent trumpets of decency and hard-earned privilege. Eric, I remember, the last time I saw him, was talking about moving away. He doesn't want to spell it out. He won't say it. He says it: 'Alien noises'. Ghetto blasters. Pyramids of voodoo speakers. 'Brutal'. 'Extreme'. These are now words of praise. Sound levels that cause blood to run from the ears. (Chris Petit, subjected to half an hour of ferocity from Bruce Gilbert, muttered in approval: 'It doesn't half clear the sinuses.')

Eric at home, cupping his ear to pick up the Brahms over the kerfuffle of dustbin lids rolling down Herne Hill; baseballs bats clubbing gay activists in Brockwell Park; the rattle of commuter trains; gangsta-rage in Brixton. Reality, Eric discovers, is chewing up

theory. Barriers of Gold Medal shockers won't defend the property against wired raiding parties.

In a white pub, tricked out with hanging baskets of petunias and geraniums (aniseed spittoons), I think of ringing Eric to tell him we'll be a bit late, but realize, after the drinks are on the table, that I don't have his number. Eric's a fine cook, and I don't want to mess up his timing. When I asked if I could bring Atkins, I forgot to mention that he was a vegan.

As we move rapidly through the last mile, I fantasize a chicken-spice aroma: garlic fizzing in hot butter. Under the railway bridge and into Croxted Road. Graciously, Eric sweeps aside our excuses. We seem to have caught him mid-sentence (striped apron and trainers), rubbing his hands together in the corridor, ushering us through to where the table is set, a small kitchen that adjoins his living-room. (I always wonder, drifting through south London, what mysterious lives occur behind the net curtains.)

Atkins is swooped, in a blur of hearty interrogation, anecdotes of other photographers, examples put down somewhere, mislaid, off-prints of lectures, towards a decision between sofa and high-backed chair. 'You're sitting in Robert Duncan's place!' Atkins pulls himself up, as if expecting this other man, this name, to appear on the instant. Hollow with hunger, he hovers with his camera, wondering how to break it to Eric that he won't be able to partake in the wondrous event that is simmering on the stove.

No problem. There's an immediate revision to the menu. Soup is produced that would restore life to a cephalopod. Eric, as he decimates vegetables or conducts with a fly-swatting spatula, denounces the egotism of recently hyped versifiers. 'Faber' is a sound like a barf in a Bavarian beer-cellar. It comes with a run of invisible exclamation points. He snuffles, chokes. The furry eyebrows leap to attention. The neck twists. A stern hand buffs down an unruly floss of hair. Mottram *loathes* and despises that throwaway diary-form poetic. Pernicious domesticity. Without reference or sub-text. 'Got up, sneezed, had a shit.' The colourful postcard, the customized anecdote. The precise form I had in mind for this wobbly homage. (I thought of Frank O'Hara on his lunch break from the museum. Tom Raworth and all the other Mottram-sponsored surfers of spontaneity. But I had the sense to keep shtum.)

Eric waves us off from the doorstep. The visit is over before it's begun. He hasn't, so he tells us, ever considered walking in town. There's a perfectly good train at the end of the road to carry him back to civilization. He's very fond of a good country stroll. Tenby or Pembrokeshire. Sea-dog, roving cultural ambassador, dispenser of arguments. Around his figure swim the shelves of scrimshaw, the poison darts, the figurines, the much-loved paintings. Our faces are turned towards this plotted interior, museum of selves, and our backs to the rubbish eddying against the park railings. Where four men were attacked and beaten at yesterday's Gay Pride rally.

Eric Mottram at 70. Atkins frames him, confident that he's got what he came for. A man who is almost as old as Marlon Brando.

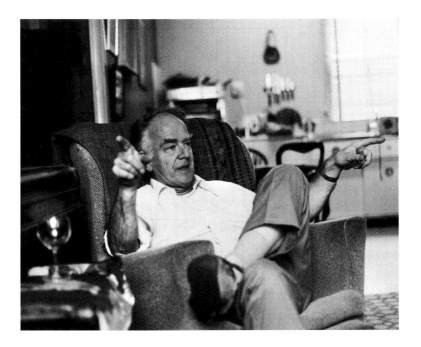

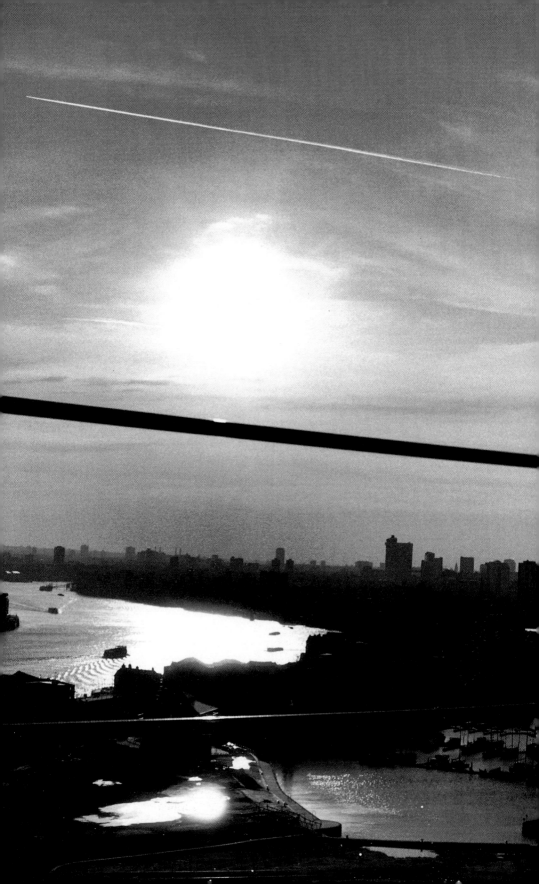

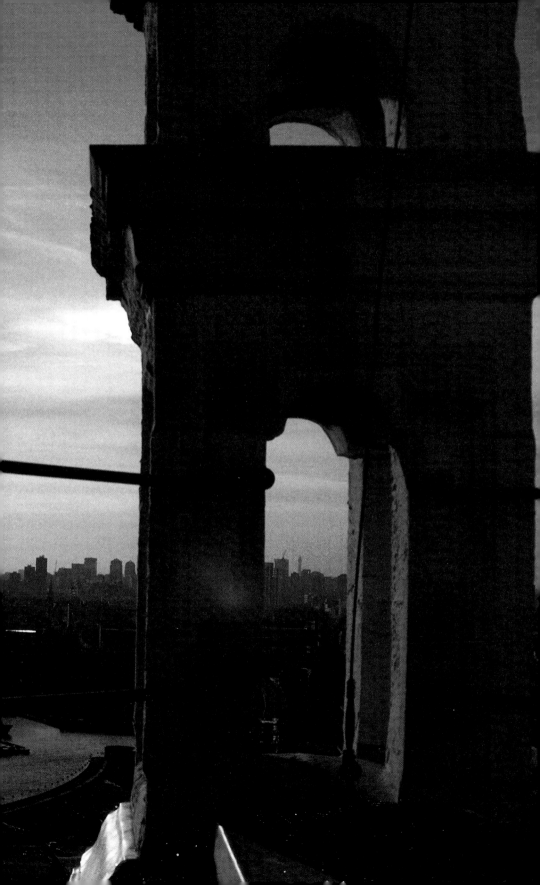

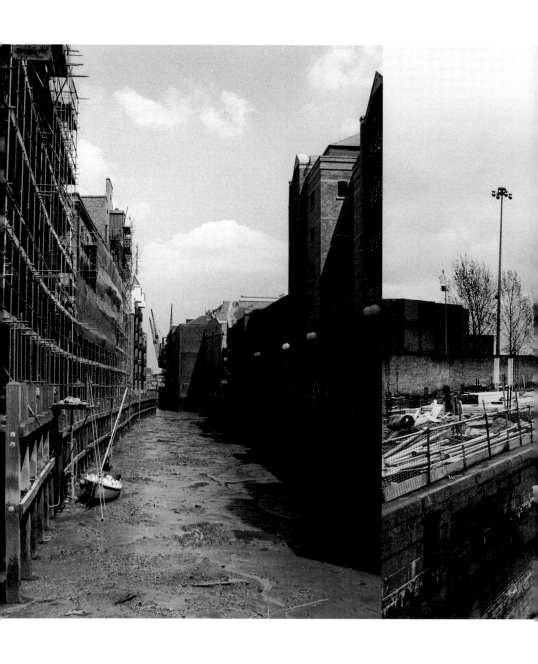

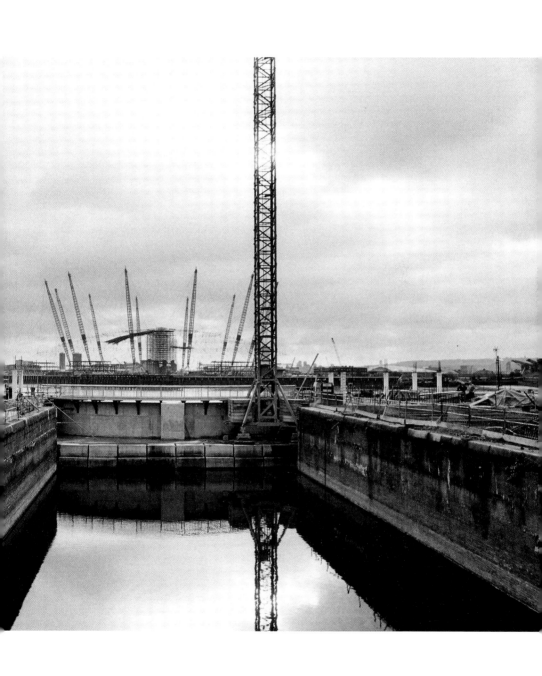

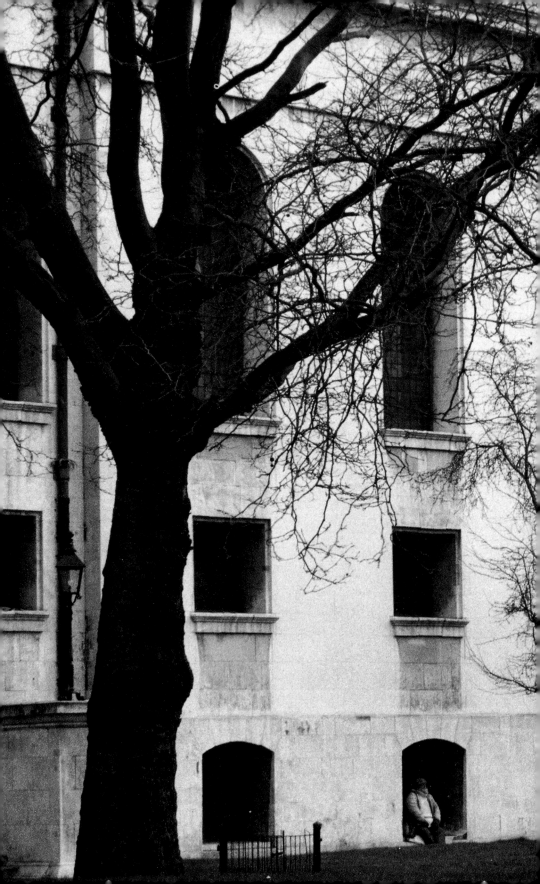

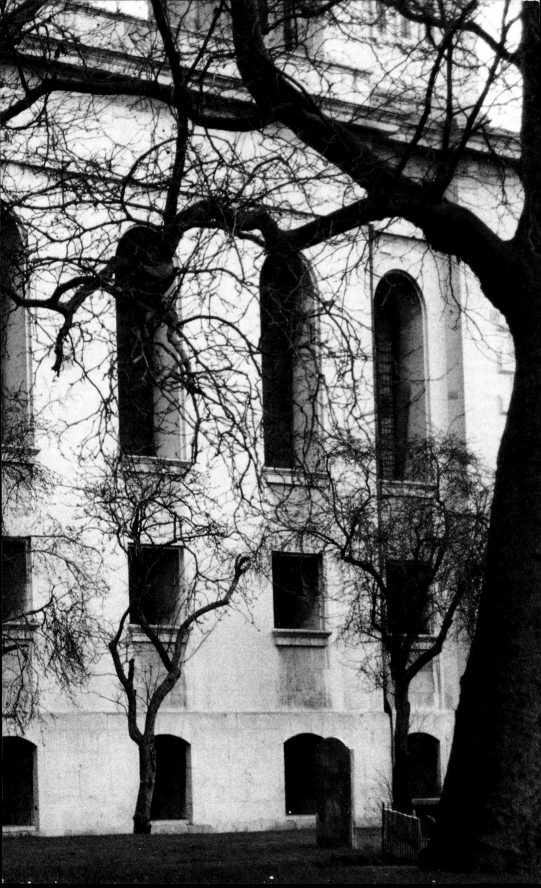

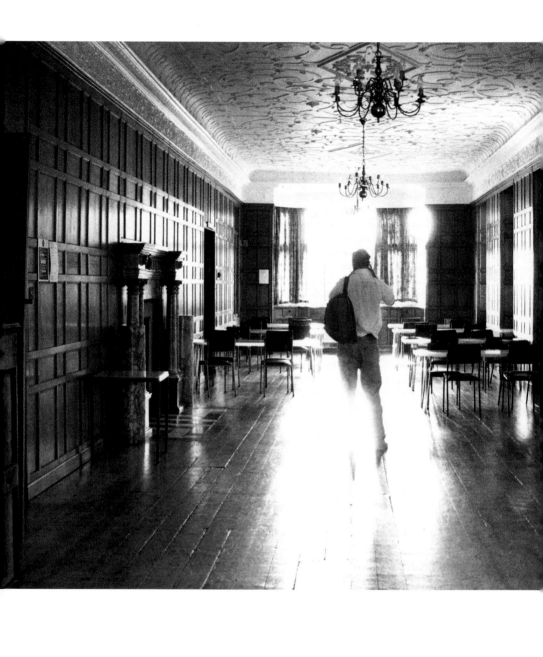

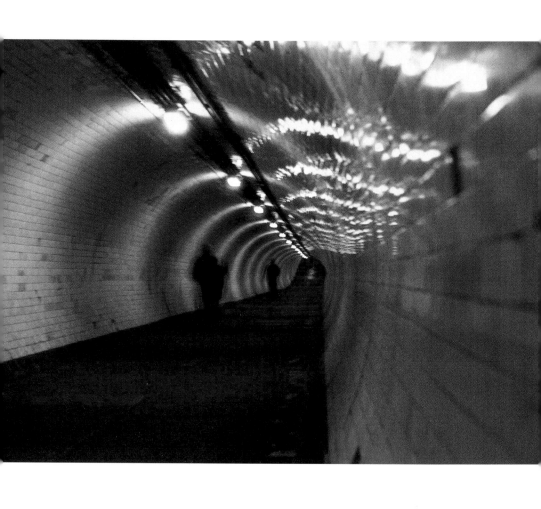

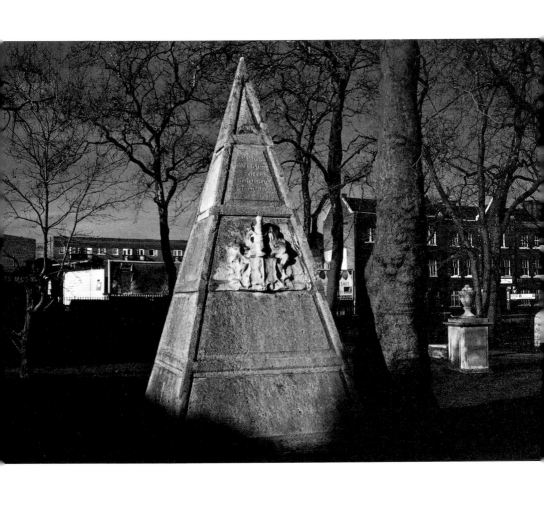

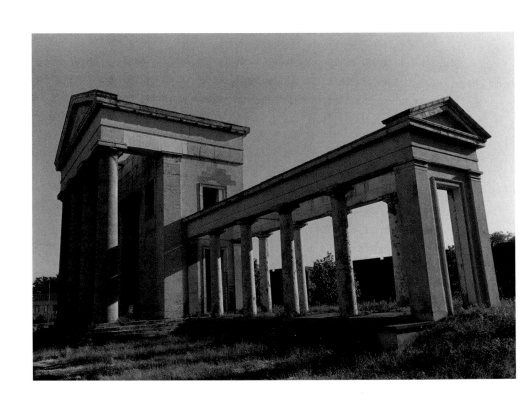

Sion ants

29 June 1994: to the London Orphan Asylum, Lower Clapton, by 7:30 a.m. On the road with Atkins again. We need to log this reluctant survivor before it signs up for an involuntary euthanasia programme. Why should a photograph matter? Another entry in the catalogue of the fabulous city, another marker. My understanding is that, given time, image will outweigh actuality. There will be more photographs than buildings. Time-coded light imprisoned in cruel rectangles. Atkins looks at the world through a letter-box. He's a materialist. He wants it all. London in a cardboard folder. The elitism of the artist: that certain sites, nominated ruins, curious doorways, privileged high-angle riverscapes, should be all that coheres. All that stands out from the mess of the moment, the rushing, babbling chaos. The noise. And the people. Excise them. Nudge them aside. Banish them from the favoured landscape format of the print. The city without citizens isn't timeless, it's frozen. Fixed. Outside the weary spatio-temporal bind, the dead system.

It's a millennial philosophy. Atkins is a Jehovah's Witness of the spirit. Whatever he notices shall live. The frames on the contact sheet that receive his mark shall be given chemical baptism, access to the alchemy of the darkroom.

We're out there on this bright, hungry morning like Victorian lepidopterists; bagging unusual specimens. Unrecorded temples that have, by some insane accident, dodged the developers. We squeeze in against the railings, search out an entry. Doric portico colonnade. Original gate piers dressed with a contemporary injunction: *FUCK*. Fuck the light, the grains and beads, the shimmering, shifting dance of it. He's hopping, swooping, craning, crawling, hauling himself onto rocks and walls – to find the one spot where he can get the job done. The freakish position from which he can show this mock temple up for what it isn't. His print, sweated over, reveals Hackney *as it should be*. More style, less history. A narrative in cryogenic suspension.

Sandstone is auditioned as future dust. The picture is taken care of. It can be manipulated into an exploitable form, but sound is free. *Early* sound, specific to this time of the day. The layers, the outward-drifting ripples: a stream of traffic spiralling off the Clapton Road/Lea Bridge roundabout, snarling incomers on Lea Bridge Road itself grinding, a yard at a time, towards duty; the odd duck on Clapton Ponds; the sluggish convulsions of the river Lea; the kettles, bedrooms, doors, newsagents, greasy pans sizzling in hot caffs. Yawns, farts, sneezes, snores. Yelps and moans. Solitary ecstatics and tender conjugations of marital familiarity.

Harold Pinter lived here. We're moving on now, exchanging the odd unconnected anecdote or random fact. Thistlewaite Road, his family home. A garden that overlooked a laundry. The foothills of orthodoxy, before the Hasidic reservation of Stamford Hill. The walk down to the river, all the dramas and betrayals of adolescence and young manhood, as mythologized in Pinter's novel *The Dwarfs*, were enacted on this turf. His journey: Springfield Park to Holland Park. The past as a diminishing resource, a dybbuk against complacency.

At the river, we turn south; following the path of least resistance, through all its twists and detours, towards the Thames. We trudge, easily and without incident, down the Viking bank, the east side. (The Lea was once the Viking/Saxon border.) Scarfs of scummy weed. Electric-green islands of villainous algae, across which mutant birds waddle and dip. They're addicted to polystyrene and industrial-strength glue. The occasional wobbly heron, all beak and elbows.

On past the junction, where the Hertford Union Canal cuts back towards Victoria Park, and down towards the tidal Lea, the defunct water-mills. We don't pay much attention to the fuss of Breakfast Television, the customized lock-keeper's cottage with its satellite disk, its muted hysteria. This is the kind of location Atkins *won't* photograph. The cutesy surrealism of the minor celebrity who is annoyed to be recognized and suicidal if ignored.

After Bow Bridge, we're out of it. In bandit country. Anything that has survived lives under the diesel fug of the stampede towards the Blackwall Tunnel. Film crews, TV crews and media sharks (art + property = lifestyle) have already stitched up Three Mills and Channelsea. Tesco's Superstore is the only place to find food – until the tapas bars and retro-brasseries get established. We hang on and are

rewarded, on the cusp of disaster, by a grease caff perched at the mouth of the tunnel. A shack that overlooks a triangle of poisoned land between the Northern Approach Road, Bow Creek and East India Dock Road.

Breakfasts are everything on these occasions; they define the day. The ingestion of the full fry (£2.20) is a necessary ritual. The fearsome sight of Atkins mopping up his double helping of luridly dyed beans. The white coffee mugs shaped from lavatory tiles. A puritanical reward, a break from the journey; scoff that has been earned by sweat and tears.

CONDEMN THE BUILDINGS NOT THE INHABITANTS announces a banner slung over one of the ruins on the run-in to the Blackwall Tunnel. I haven't, as yet, broached the goal of our quest: Prince Henry Stuart's Jacobean palace in Charlton Park. (The goal means nothing to Atkins. Any excuse to be out there, scratching at it, logging the city. In movement between static frames, quiet epiphanies.) There is a psychic hotspot across the water; useful prompts waiting to be scattered. The local historian Ron Pepper proposes a direct link between Adam Newton, Henry's fated tutor, and the Priory of Sion. Cultists who infect the cycles of received history with best-selling heresies. We have already, on our early up-stream yomps, hunted out these fugitive signs, Sions and Zions: from Twickenham to Mortlake to Lambeth. Alexander Pope, Dr John Dee, Elias Ashmole, the Tradescants, father and son.

Today's walk is exemplary. We don't know what we are looking for. And we won't recognize it even if it bites our ankles. Plodding southwards through the Isle of Dogs is a profoundly depressing experience. We align granite pyramids with the winking, idiot eye at the apex of Canary Wharf. Tweet, tweet. Tweet, tweet.

Two pathologically unselective schoolgirls, brandishing clipboards, decide that we are suitable candidates for a questionnaire.

'Do you live on the island?'

'No.'

'Do you work on the island?'

'No.'

'What do you think of the transport system?'

This one is clearly beyond our remit. We stare at our feet. I've been marooned a time or two on the DLR ghost train, but that was

in another country. We've regressed, opted out. Speech itself has become burdensome.

In Greenwich, we hop a ferry to the Thames Barrier. I toast my lungs with a black cigar to gift Atkins with a 'better' photograph, clouding the horror of the true picture. He fiddles with his exposure, his focus, to keep his mind off the river. He doesn't like water. Water and double-beans and the gentle swell running around the retired Russian nuclear sub, now moored as a tourist attraction, do nothing to pacify a sensitive digestion. His only consolation lies in the fact that Paul Burwell is not at the wheel and we're not making another run at the offshore forts at the mouth of the river.

Up through Maryon Park, a Romano-British camp once excavated by Flinders Petrie. Now we have a clue to the mysterious crop circles noticed (on the site of Antonioni's *Blow-Up* lozenge) on our previous visit. A satellite scattering of knotted condoms. Illicit sex in the grass. The last flakes of green paint from Antonioni's set dressing are peeling from the wooden fence.

There's a dry wind in the Hanging Woods. A drench of exotic animals, deer, peacocks, neutered wolves. Creatures imprisoned in a small enclosure as a residual memory of royal menageries, hunting packs. The heraldic beasts of Henry's court.

One road to cross and into Charlton Park. After so much time on tracks and in scrub woods, it's impossible to calculate the speed required to dodge suburban traffic.

We are obliged to check the acorn plinths, the scorpions. We cannot, on this occasion, explore the upper reaches of the house (library shut on Wednesdays); a *major* film, a historical drama, is being shot.

Excellent. Access should never be easy. If a story is worth excavating, it's quite right that the latter-day guardians should sod you about. Should disguise arcane mysteries in layers of bureaucratic obfuscation: lunch clubs, adult literacy, dances for the blind.

There are gabbling hand-sets on the stairs, film-industry auxiliaries who dress like Joseph Beuys. Dry fishermen with antelope-skin desert boots. Lunching extras colonize the rose garden, temporary Jacobeans. Delirious wafts of location cuisine from the caravan. Costumes billowing on a box hedge. This is another day when we'll have to improvise, wheel off to some secondary target.

Marc gabs on about red English bricks. He's an ex-brickie, so he says. (Ex-plasterer, ex-welder, ex-heavy metal roadie, ex-Catholic, ex-long hair, ex-hair-at-all, ex-husband. That's plenty of X's for an artist dedicated to photographing everything in the world in order to prove his own existence as a sentient being.) The walls of the private garden are, on their own, worth the walk, but it takes a professional to appreciate them, the gradations of colour, rose to blood. The warmth. The hallucinatory patterns with their Islamic repetitions.

The plaque honouring the first mulberry tree in the realm of England is overgrown. Where else but Charlton would you find a public toilet (closed for the duration) designed by Inigo Jones?

Diagonally across the Horn Fair field. Now that we have nowhere to go, except onwards, we speed up. We race to not get there, to un-arrive. Unwritten territory replete with pre-fictional possibilities. Nothing known. No cultural markers. A condemned high-rise block. Woolwich Common. Meadows and steep, ungrazed terraces. Hospital-barracks subverted by woodland. We're moving into broken-field suburbia. Military convalescence and discreet lunacy. Healing zones on the perimeter that meld with over-ironed golf-courses and the formal geometry of neat burial grounds.

Old London is lost in a heat haze. We sneeze and sweat in the early afternoon. Paddocks of pollen lift towards the timberline, clay aspiring to chalk. We puzzle over a laminated map which has been placed at the entrance to this tame forest with the sole purpose of confusing pedestrians, by making them doubt all the instincts that have carried them so far. *YOU ARE HERE!* 'I'm not,' you want to scream. 'I never was. That was another person with my name.'

We are consoled by the demonstrably solid eccentricity of Severndroog Castle, with its Mervyn Peake title. There is no access to this triangular folly whose boarded-over windows have been invaded by prophetic shadows. That seems to be its only purpose: a reservoir of darkness; a water-tower to sustain walkers who have laboured across the sun-bleached fields. Pushing reluctantly on, there is a shock of excitement, at the turn of the path, as we are exposed to the drop; the plunge into wide-screen landscape format, after the narrow black verticals of the woods. Blue-grey light of roofs and roads speeding to the horizon. A sudden vision of the ancient

pilgrim's way. 'View' at its excessive best. A legitimate excuse to halt us in our tracks.

Eltham Cemetery is an obvious conclusion. It's as far out as we're prepared to go. Eric Mottram talked about filming in some cemetery and called it 'Eltham', but it couldn't be here. There was no Thames in the distance. Just the Rochester Way mooching down towards the great orbital river of the M25. Any further out and we'd lose it completely. We'd never return.

We walk the neat avenues invigilating tombstones for names that might be incorporated into future fictions. There's not an Atkins to be found. The photographer might have to be written out of the story. Spin-dryers grind bone-coffee in the rusticated crematorium.

Backtracking: over the ridge of the hill and down towards Woolwich Old Town (ghosts of rioting soldiery). The re-engagement with civilization is signalled by contour lines of increasingly awful puns, wordplay that strips the enamel from the teeth. From the mock-Celtic discretion of *Dunroamin*, the multiples of Voysey, sunburst porches, to *JUNK & DISORDERLY*: salvage pits with no pretensions to chintzy antique status. Glimpses, on the long descent, of the distant, glittering river.

A foxy black woman striding uphill, on the far side of the road, whips Atkins back on his heels. A swift expulsion of breath like an asthmatic seizure. The life-force writhing inside the abbreviated summer dress is like foreknowledge of the Second Coming. The photographer gasping over the one who got away. The chasm between his twin modes of operation: cold eye on landscape and the intimacies of the studio. Out in the weather, *en plein air*, he is detached, watchful, ironic. Quick to notice vulnerable structures. He doesn't want to photograph anything that will still be there tomorrow. Back in the studio, he controls his own environment. Shuttered windows, heavy drapes. Naked bodies in their struggle with gravity.

Duty drags him towards the river: the free ferry, a welcome pint within earshot of striking signalmen. A melting sun dips as we work the diagonal, back to Hackney along the Northern Sewage Outfall (butting against the drift of our own waste products). A high-country tramp, accompanied by strong evening shadows, down an avenue of pylons. Songs of electrification.

By now the Manichean divisions of Atkins's art are worn on my face. I am divided, split, striped by a twelve-hour exposure to sunlight. I have become, slogging homewards, a meridian metaphor. My west-facing cheek is tight, red, cooked like bacon. Its east-facing partner is blue, under the shade of a baseball cap.

It was the final descent on Woolwich that gave us the phrase we had, all unconsciously, been searching for. As we swerved out of Eglinton Road into Herbert Road, I noticed it. A partly demolished pub with a few letters still framed on the tiles. A found poem:

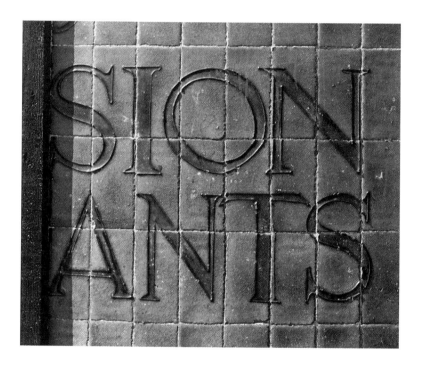

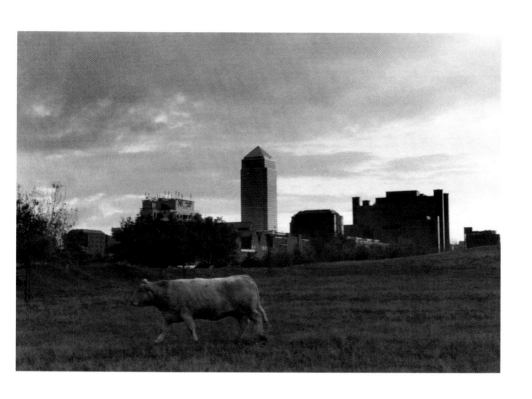

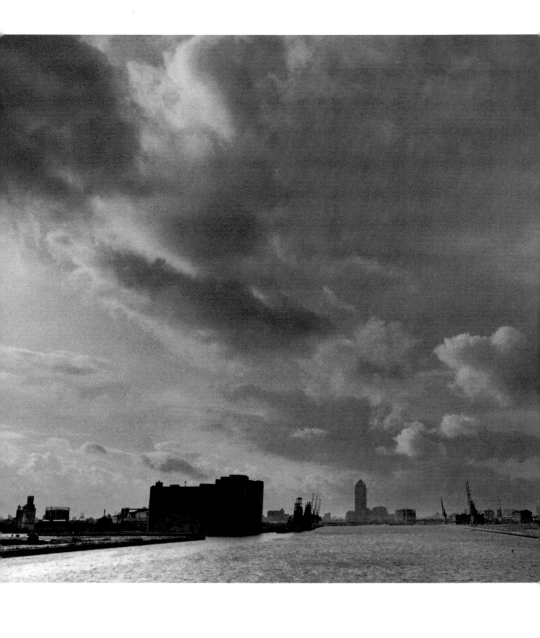

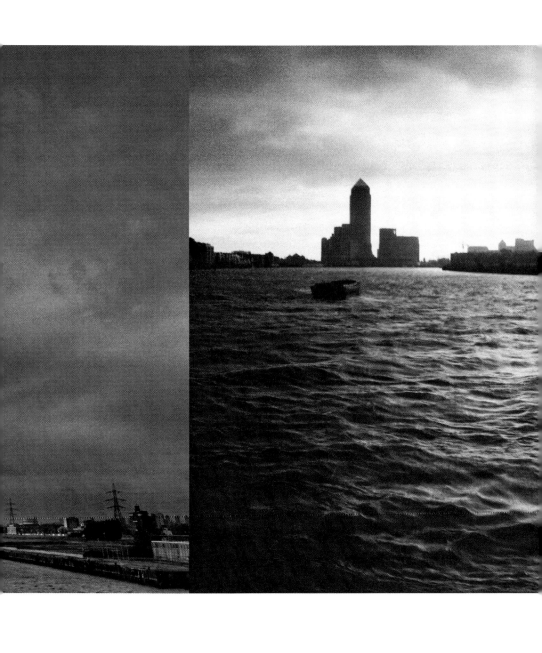

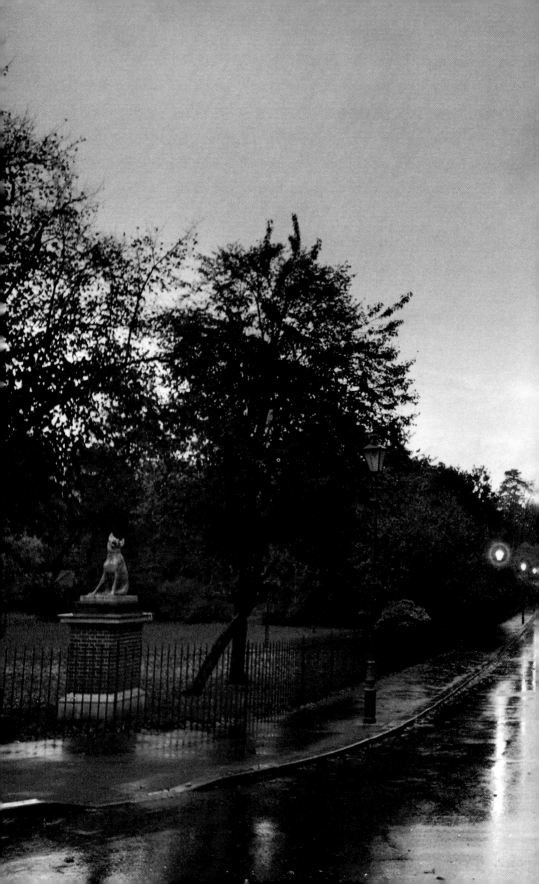

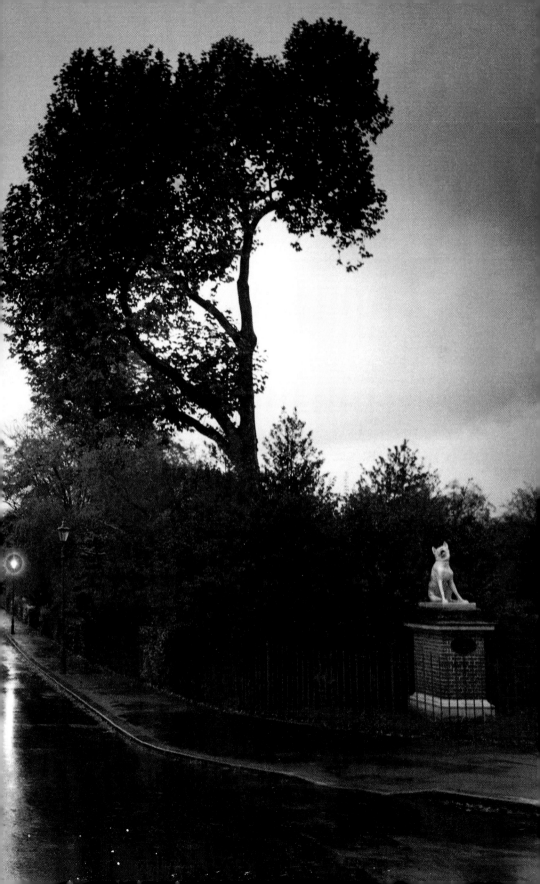

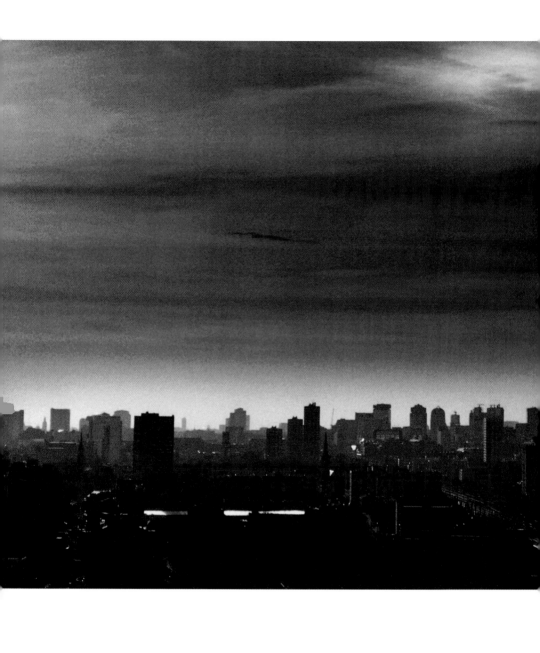

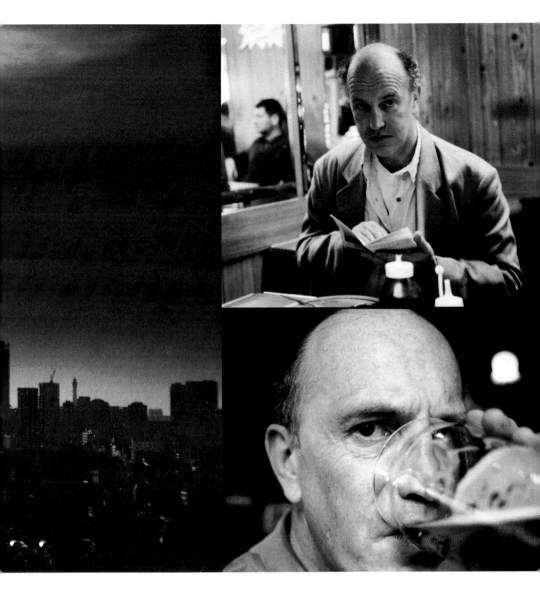

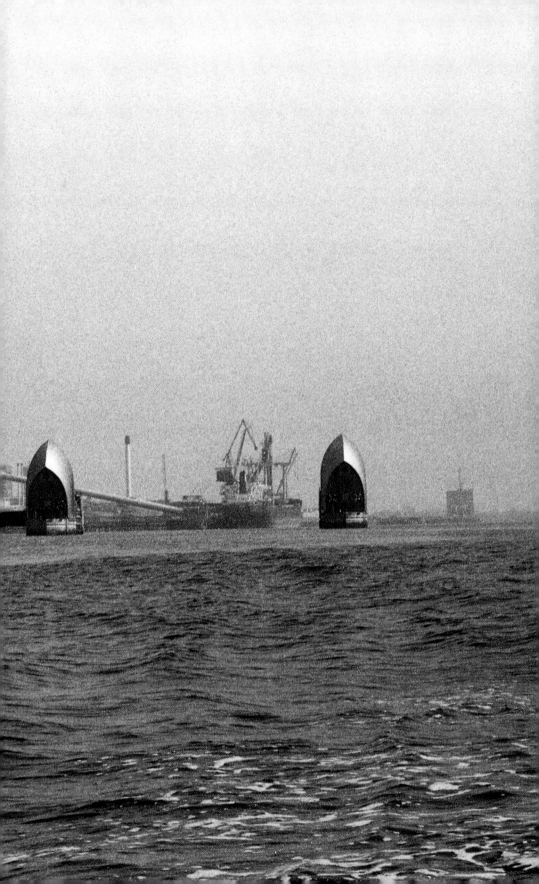

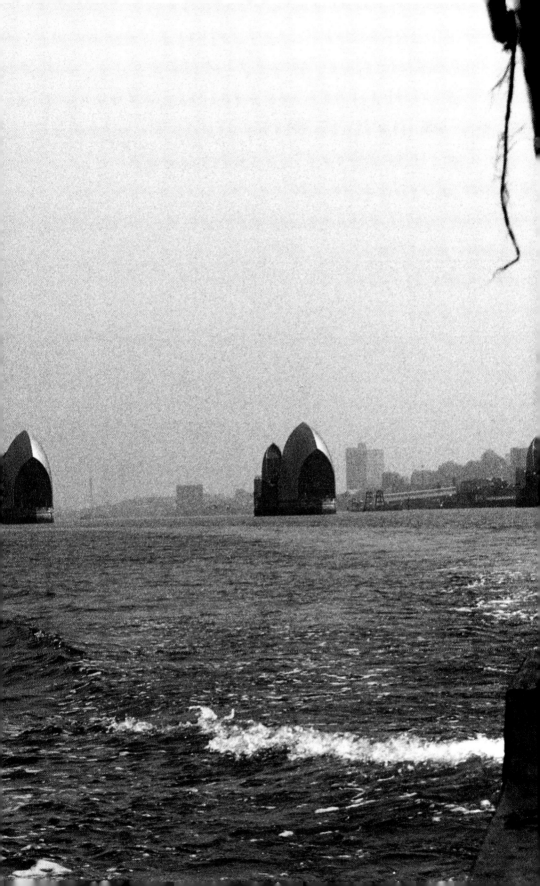

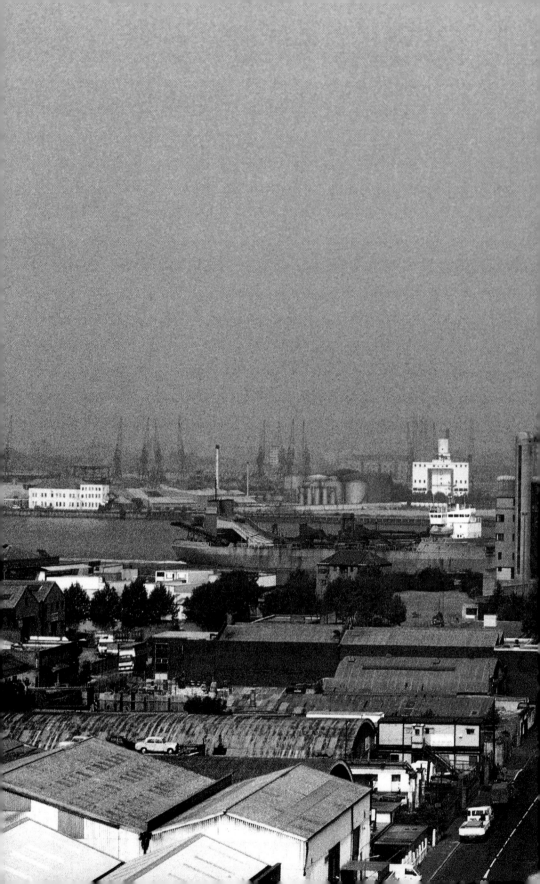

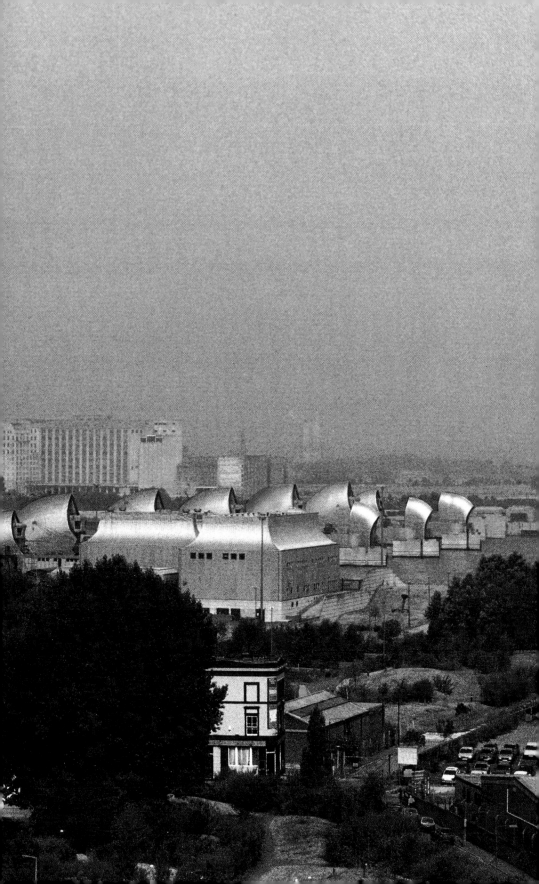

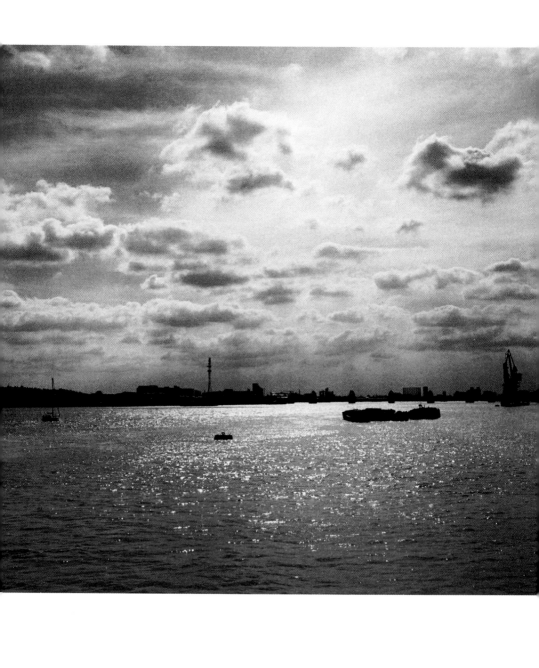

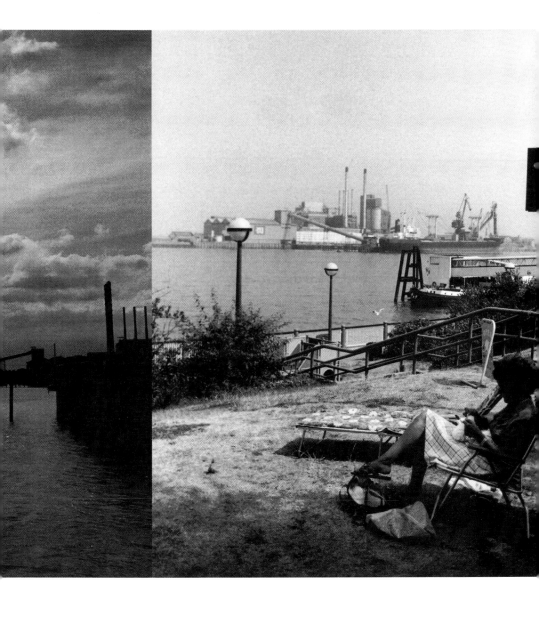

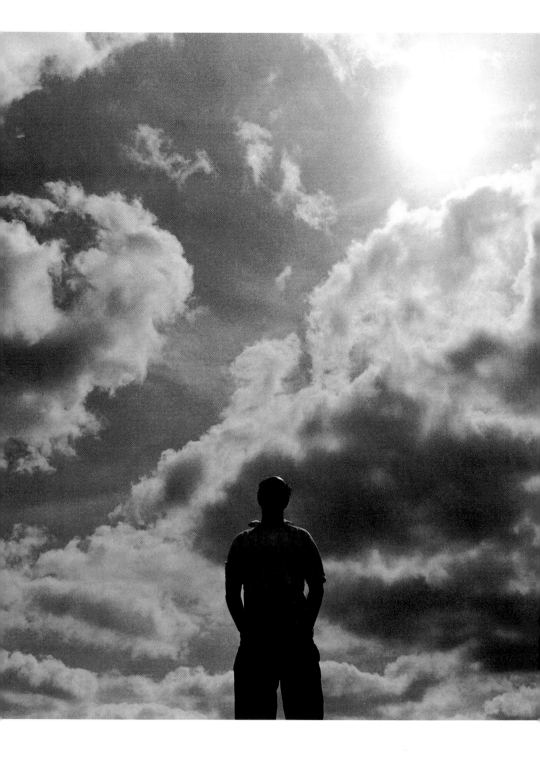

Watching the watchman

Occasionally Insanity roll'd a sly Eye-ball into the picture.
Treatises on 'Parageography' arriv'd, with alternative Maps
of the World superimpos'd upon the more familiar ones.

THOMAS PYNCHON, *Mason & Dixon*

Friday, 23 May 1997. Alan Moore, still having 'something of the night' about his person, arrived early. He had decided to bivouac in a hotel, so that he would be fresh for the walk to Mortlake in the morning. I realized, as soon as I saw him standing with his bulging bag in the hallway, that this time, without question, Alan *was* the walk. (I'd done it before. Marc and I had worried, time and again, at this locale: the free-standing arch in St Mary's churchyard, the tomb carvings and inscriptions, Sir Richard Burton's stone tent. Dr Dee was a subject I'd never managed to write about. That section had been deleted from my novel *Radon Daughters*. The *Angel-Magick* opera, pitched by John Harle to Elvis Costello, had resulted in a pleasant Kensington lunch and the immediate decision by Costello that Dee was altogether too dark for his residual Catholicism.) But now the tracings of our journey across London, onto the skin of the Northampton visionary, would be the day's narrative.

Alan and I had talked about Dee and Mortlake for years, on the telephone and on the infrequent occasions when our paths crossed at readings or performances (we were both well dug into our own territory and emerged reluctantly). I had imagined that he'd be content to let me visit the churchyard on his behalf. Or that he'd cab in one afternoon with a mate and a camera. Not so. I suggested meeting him somewhere along the route, Putney or a riverside pub. But Alan wanted to do the whole thing. He stepped into the house equipped with a scrying mirror and a conjuror's kit of angelic tables, books of the law, cabbalistic treatises. The full Harry Price away-day kit. (Peter Ackroyd, writing *The House of Doctor Dee*, had no interest in riverine suburbs. He re-located the magician's lair to Clerkenwell. A zone that had a peculiar resonance for him. One of his favourite restaurants was on Clerkenwell Green, where, from the favoured

window seat, he could watch the Masons with their black cases massing like crows. As with *Hawksmoor* and Spitalfields, his gesture proved to have a prophetic influence on estate agents. Property values rocketed in the wake of his novel. Sharp developers should snap up proof copies of future Ackroyd fictions.)

It was curious how this walk, a marriage of convenience between chiropody and alchemy, seemed to flow from the obsessions that Alan and I had separately exploited: gothic mystification in Whitechapel, surveillance and sculptural coding in the City, Lord Archer's penthouse and the paranoid poetic of Lambeth and Vauxhall. Magic and feet, that's what it was all about. The excuse for a greasy-spoon breakfast (where would the *roman noir* be without it?). Newspaper headlines on white paper like concrete poems that must be obeyed: *ARTIST GUILTY OF BODY SNATCHING*.

We were a thrift-shop Dee and Kelley cupping our ears for whispers from tired stone. Photographing convex mirrors outside burger joints, CCTV systems on tall poles. Every step shadowed a previous fiction, a chunk from one of the books, an Atkins photo- graph. Alan drudged the long detour, after Vauxhall Bridge, when the river path is banished inland, past cold-stores and dogs' homes, on the promise of a Putney pub which Atkins and I had patronized, coming in from the other direction. With the dust of Alexander Pope's grotto on our boots.

As the sun dropped, Alan recovered. Light was a marvel, thread- ing the leaves, gilding the faltering magus's long hair into an iconic aureole. The world of appearances was on the cusp. I anticipated the lavender drench of the churchyard.

Walking was dreaming. Alan, his target achieved, fumbled with the scrying mirror: an oval of sky, the church tower, the vanishing self-portrait. I knew that this light could neither be photographed nor described. I imagined instead an obelisk garden, an enclosed space in which obelisks (sunsets realized in white stone) bred and grew until the souls they commemorated were ready to receive them. Pynchon again:

> . . . a sudden Vista of Obelisks, arrang'd in a Double Row too long to count, forming an Avenue leading to the Folly. In this Sunlight they have withdrawn to the innocence of Stone, into being only

Here enough, to maintain the Effect of solemn Approach . . . some-
what larger than human size, almost able to speak . . .

Come this far and London loses its gravitational pull, the drag of
dirty words, the textual palimpsest. Between Mortlake and Richmond,
reversing the ride Queen Elizabeth made when she wished to consult
Dee, is a green path. Leading to follies and fountains. Metaphors
of benevolence and continuity. Gardens and palaces. Privileged
places we could visit but not occupy. Temporary visas for Arcadia.
Permission to log the post at Teddington that marks the limits of the
tidal Thames. Marc, months earlier, had pissed against the pillar on
the Isle of Grain that stood for our starting-point. This you may
define as river; the rest is the formless sea.

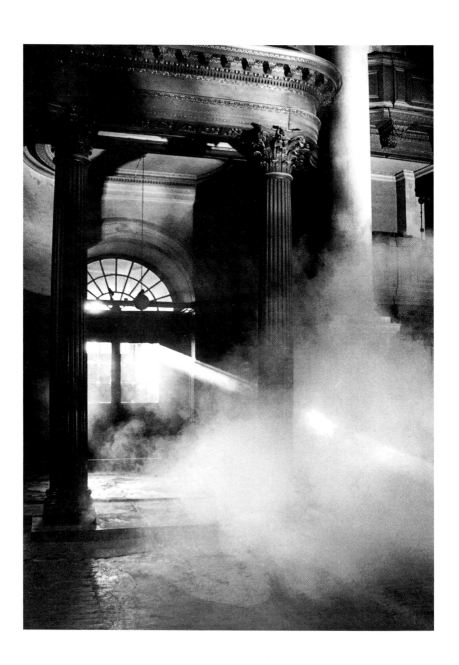

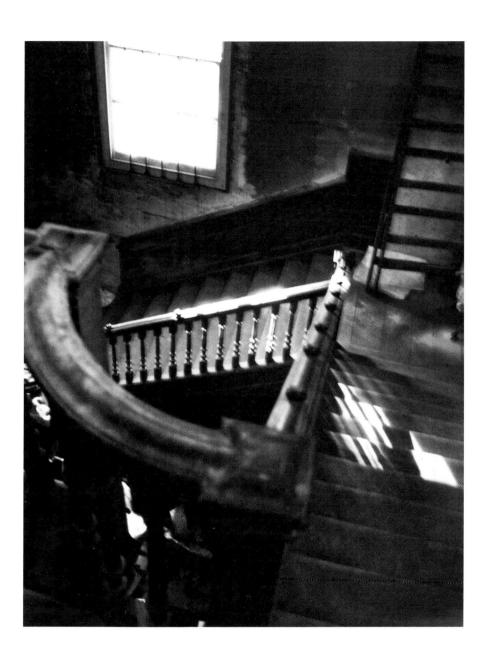

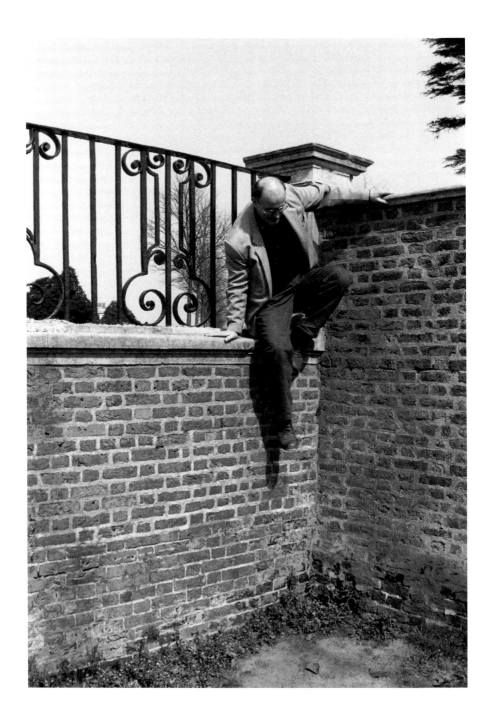

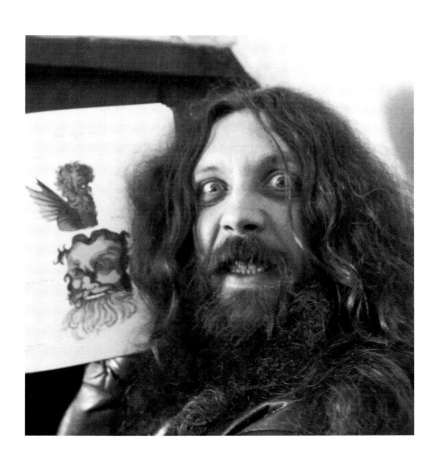

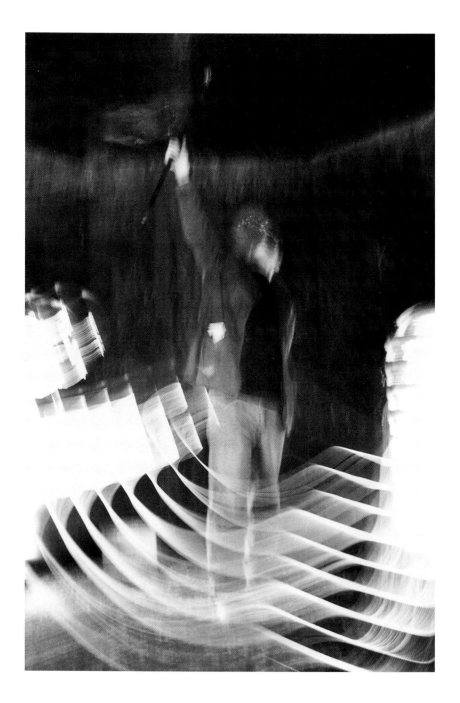

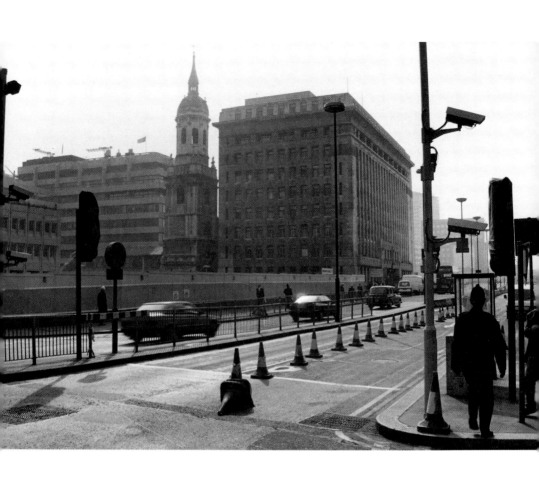

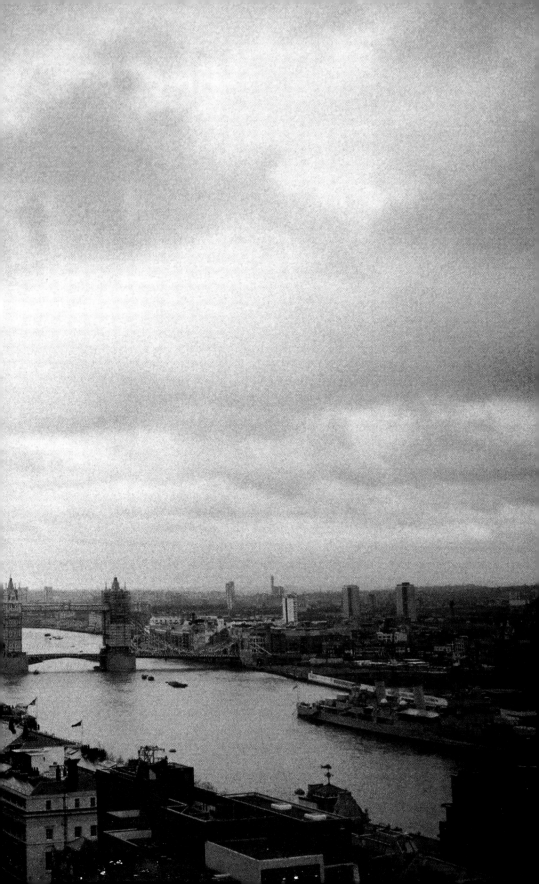

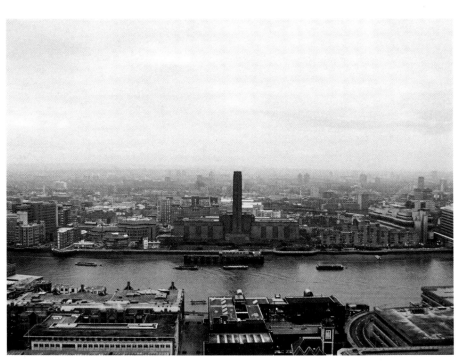

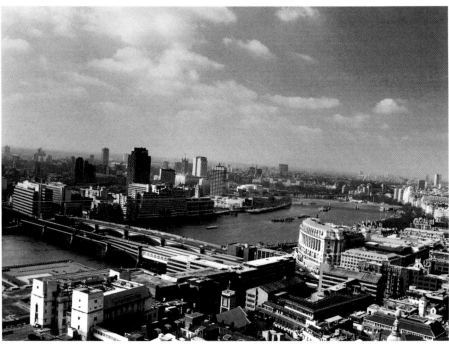

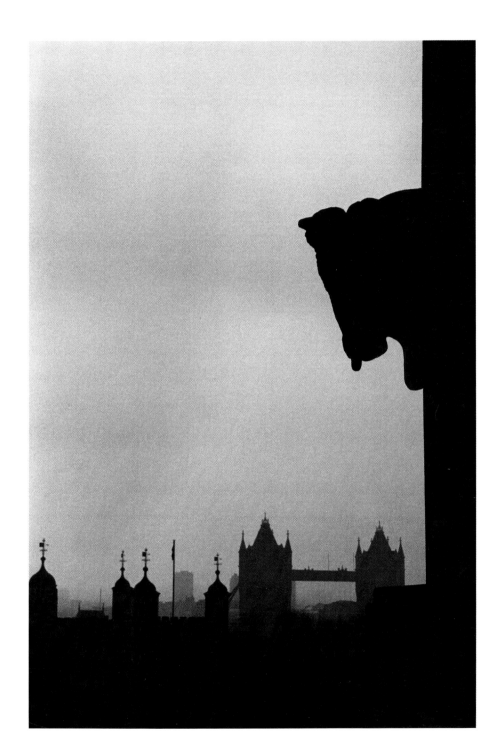

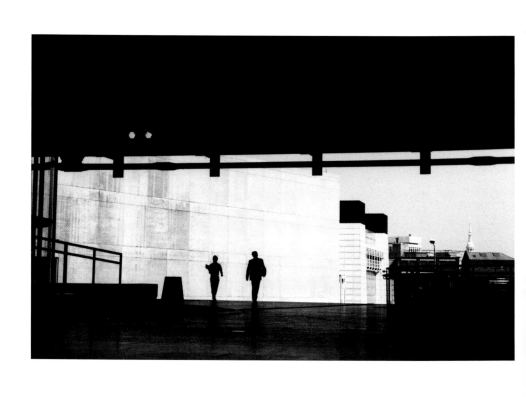

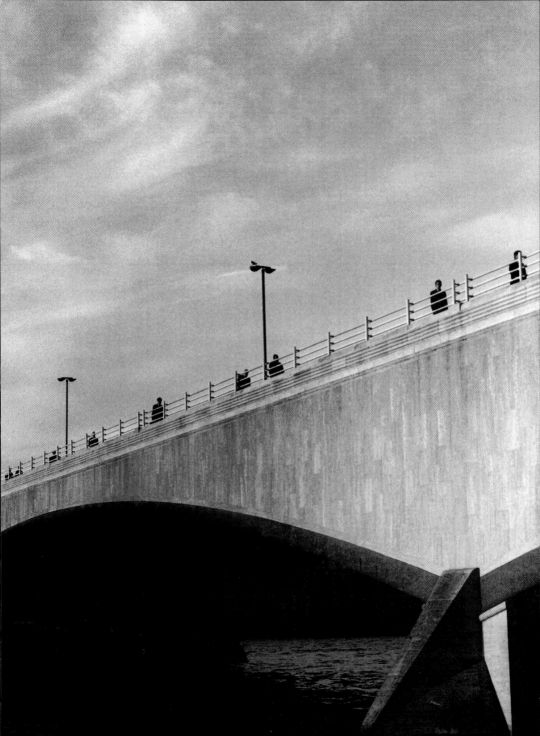

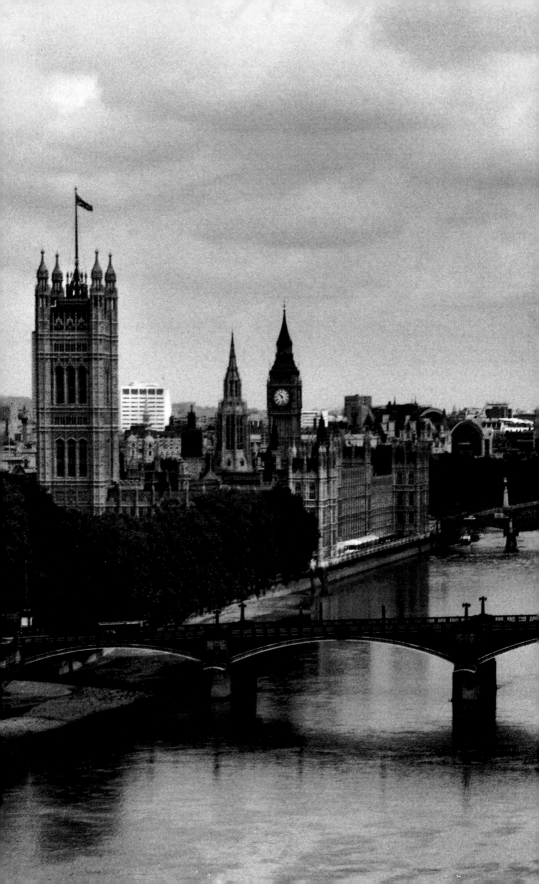

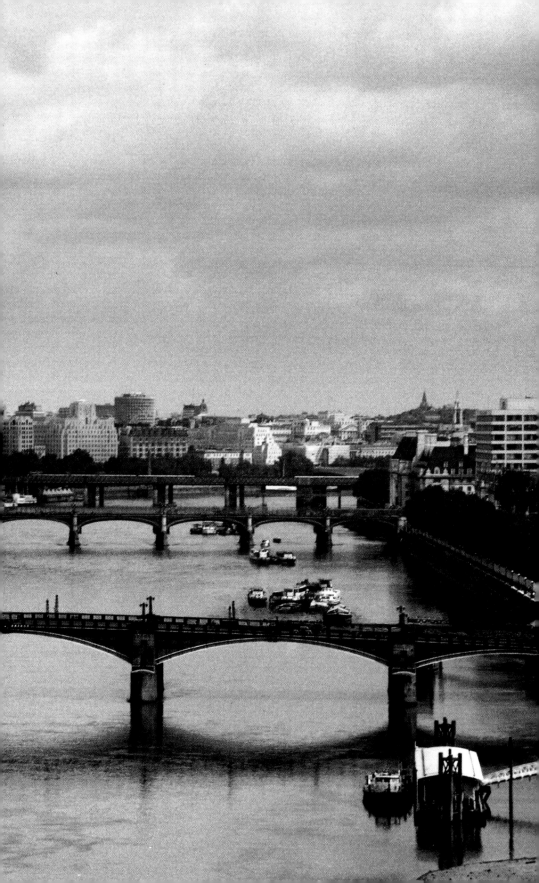

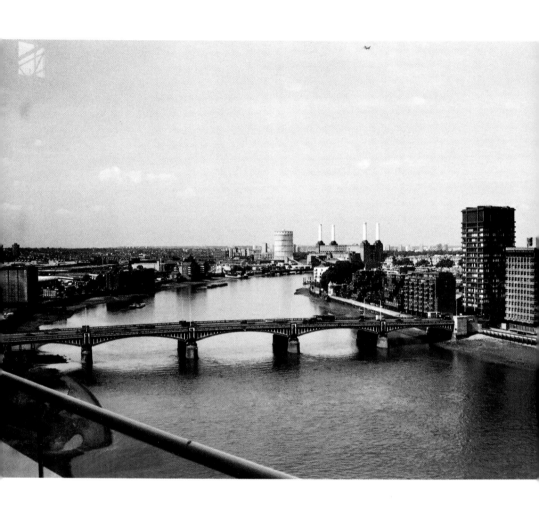

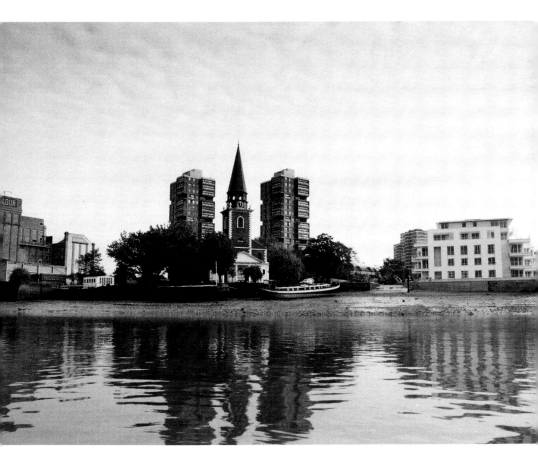

Bishop's Palace, Fulham

Sometimes the research comes after the book has been completed. That's how it was with *Radon Daughters*. For some reason, I wanted to walk Marc over the ground where Todd Sileen, the malignant pegleg, and his visionary companion, Rhab Adnam, had stamped and fumed on their riverine trek to Oxford. Marc's images would authenticate events that had never happened. I'd witnessed them on that fogged strip where memory messes with dream. I'd faked another man's diary.

Now we were back in the courtyard, with the fountain, and I felt obliged to replenish the coins with which my fictional character had filled his pockets. Atkins documented this fantasy. The light was real, stolen from the movement of the leaves, the drift of the river. He showed me the stone acorns that I'd forgotten. The pattern of the windows, some of them with spectral figures, reflections. A tree, framed in the archway, suggested forest or parkland beyond this quiet sanctuary. I (who?) sprawled on a bench, leg stiff as a plank, complacently watching the construction of this new fiction.

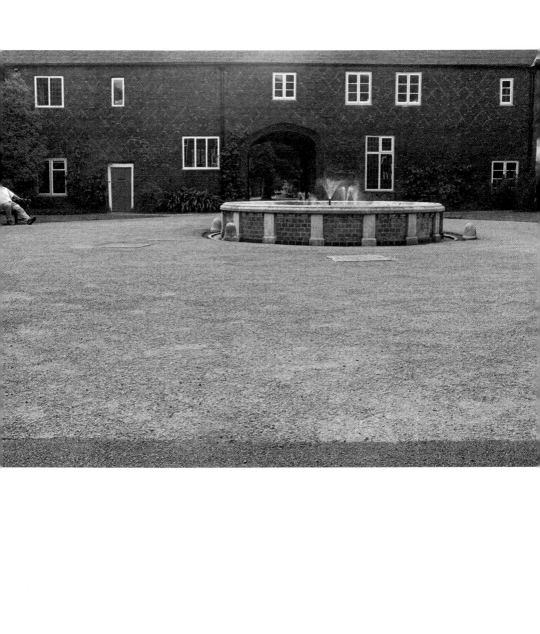

Hungry ghost

19 July 1970. The end of a short walk. Coming back down Holly Street (work ditch), we looked, on impulse, up at the tower block. Anna was cheered by these signs of human habitation, but I am uneasy: the height, the isolation, some of the windows already broken.

A man the far side of Middleton Road stumbled, held himself upright, then had the legs go from under him, drunk; tipped onto the pavement. We hesitated. He did not have the drunk's magical balance, the illusion of being on a wire, an animated earth-puppet. When he fell I crossed to take a closer look. There was a dark trellis of blood running down one side of his face. His hands were also covered in blood, he held them open, away from himself. I folded back the cuffs of his jacket. The wrists had been cut, dug at, with a penknife or a kitchen knife. He made no move to resist me. I tied, with a dirty handkerchief, the wrist that was still bleeding. Anna stood off, watching.

A window opened in the house, an old woman leaning out, shouted that I should leave him; she knew him, the matter was in hand. The blood was now spread, as if by a lawn sprinkler, across the pavement and up the steps to the door – so that the man had come, not as I first thought from the pub on the corner, but from here, the house. He must have returned, saddened with drink, gone to his room, cut the wrists, both of them, the left with more force than the right, and then walked out, instinctively, to the street, where he had fallen.

The old woman called him Denis, told him it didn't matter, pushing a lighted cigarette into his mouth, where it hung like a severed lip. Denis begging to be left alone, to die, tears running into the blood which was dry on his cheek. But the old woman stood over him: 'That's right, Denis, she was no good, you're well rid of her.' Denis asking for a letter to be read. The old woman chanting to herself, 'Don't worry, she's bound to come back.'

A younger woman, pretty, bent over to look at Denis's smashed face, yellow pants showing as her tight red dress lifted. She had been painting her nails, a small crimson bottle in her hand. Denis struggled, asking again for the letter to be read. The old woman rifled his pockets, which were all empty, saying, 'You see, Denis, she wrote to you.' But there was no letter.

The ambulance men took more than half an hour to arrive. The one in authority had not bothered to put in his top set of teeth. I walked away then; Denis was resisting, the old woman telling him to go quietly, to let the doctor have a look at him. There were spots of blood on my feet, which were in sandals, the right one blue, the left one green.

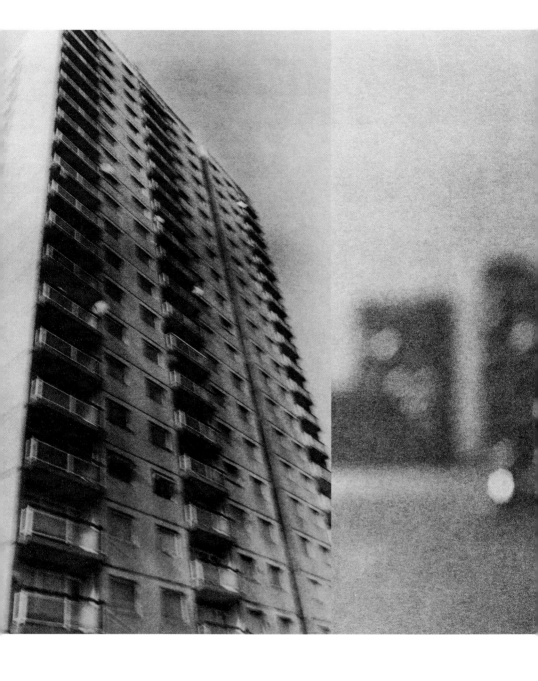

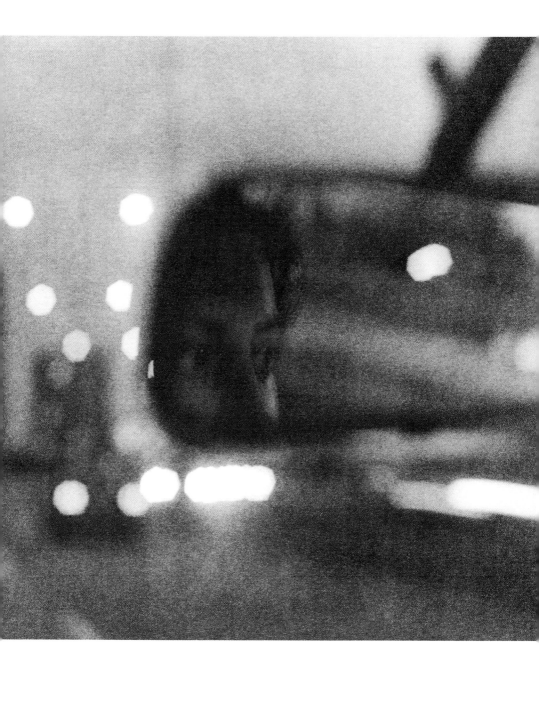

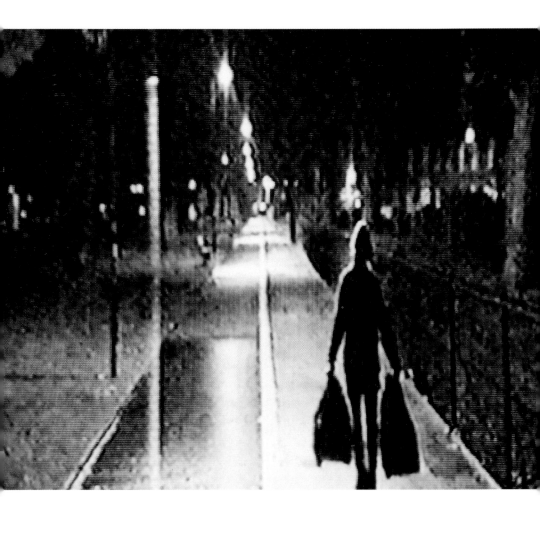

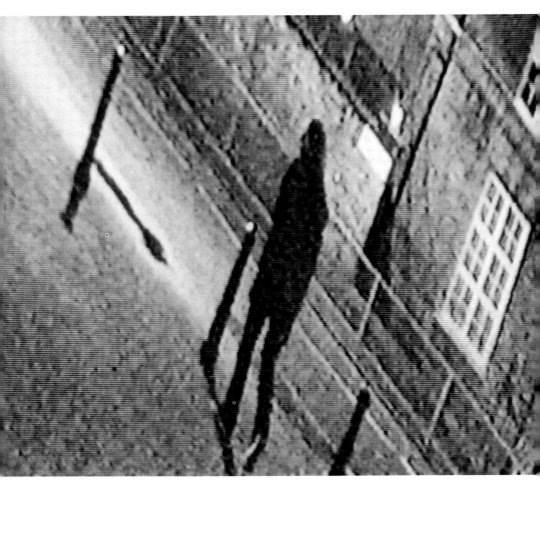

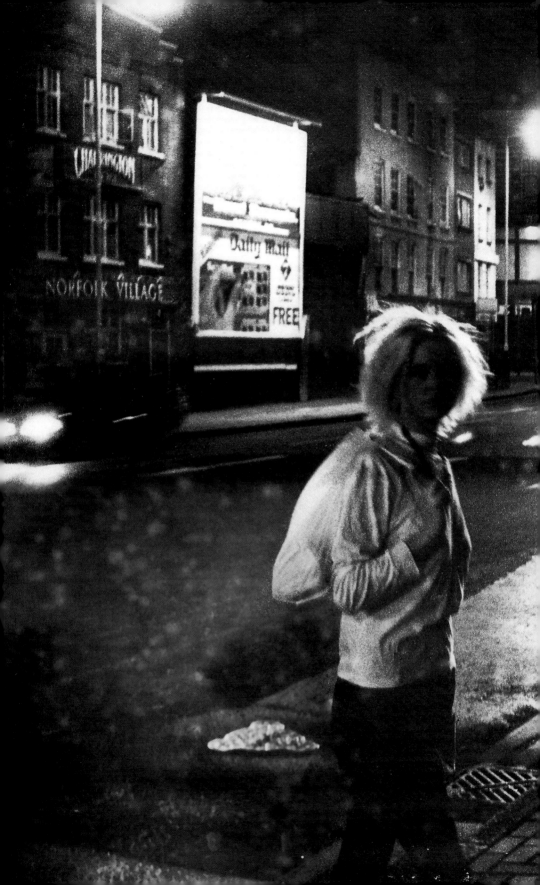

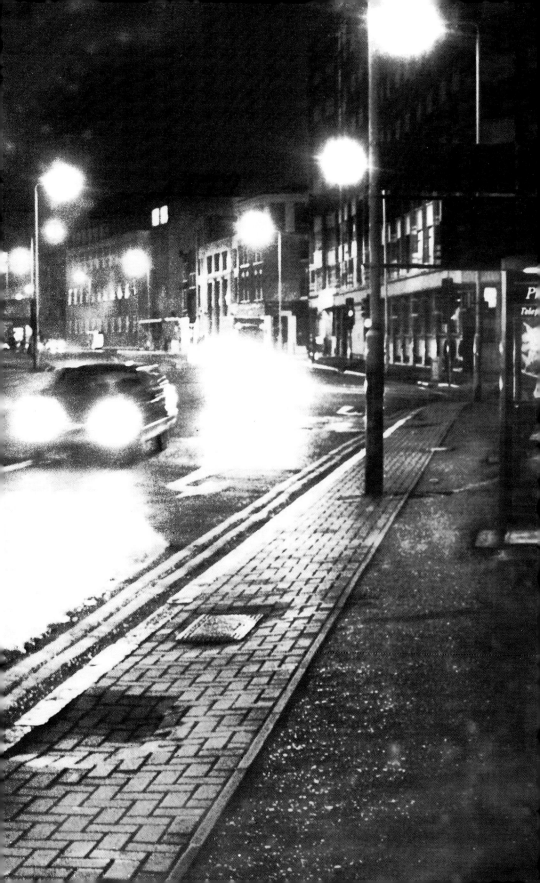

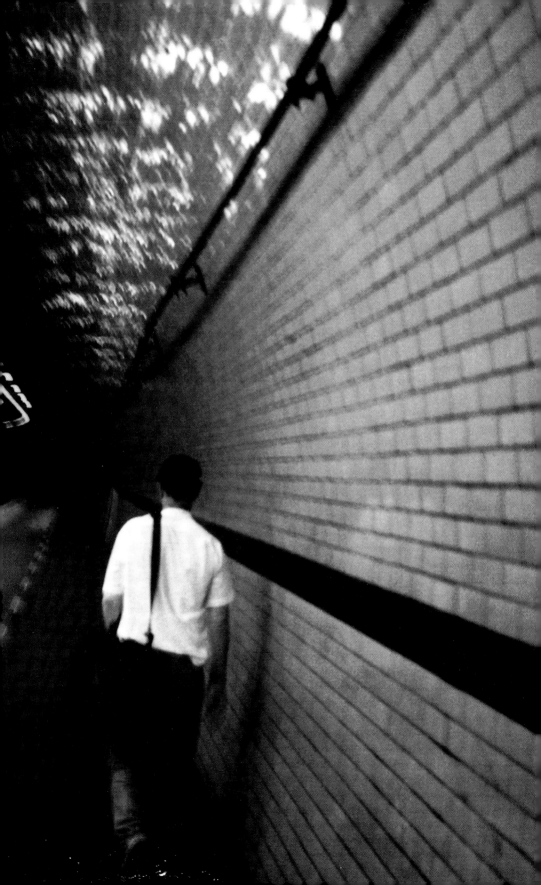

The tree that secreted coins

I had a long discussion with Marc about the difficulties of photographing absence. How could he show Rachel Whiteread's *House* when it was no longer there? Awkward squares of replacement turf? Some change of temperature caught on heat-sensitive film? A predicted accident in the darkroom? How could he find a high-enough angle to demonstrate the brick outline in the grass, all that remains of the vanished church of Mary Matfelon? Or recover the meaning of the story of King Cole, the Australian Aboriginal cricketer, from a tired eucalyptus tree in an East End park?

How, it was more pertinent to ask, could I write about Whitehead's artwork, dedicated to memory, committed to erasure? I visited the site many times. I found a wounded tree, a vulva-gash padded with waste. A beer bottle. Traces of an alfresco meal. Coins in the long grass which I arranged on a brick. (Coins I associated with the ritual offerings left at the feet of the Ripper's victims. With the random scattering on the pavement of Cannon Street Road, outside the hutch in which the body of tobacconist Abraham Cohen had been discovered. A fee for the ferryman.)

Marc, arriving at Wennington Green, without my knowledge, later that same afternoon, the sun dipping behind his shoulder, noticed my still-life arrangement. He decided that this was how he would capture absence: his own shadow, feathers erupting from the epaulettes of a shamanic cloak, falling across the bricks. He accepted the coins as a magician's tribute.

Arnold Circus

A curious elevation, a mound from which radial roads move out, as if in answer to a riddle. A place to be photographed at dawn or dusk. Favoured light diffused by tree cover. Dreadnought flats that have replaced the rookeries of Arthur Morrison's Jago. An overhead frenzy of small birds on Sunday-morning walks to Cheshire Street market.

The bandstand, with its tiled cap, is a focusing device. Patrick Keiller passed through on his Edgar Allan Poe pilgrimage in *London*. Golden, remembered sun-showers, the sound of children playing. Keiller returned to do a radio interview, a conversation with Patrick Wright. Bangladeshi smokers, junior gang members, lounged at the margin of the event. The bandstand was their place.

Wright's first question was complex, with improvisatory sub-clauses, backtracks and few pauses for air. Keiller, resolutely slow-firing, waited. Impossible to tell if he repudiated Wright's argument, or if he thought the structure of the sentence so elegant that any comment, beyond a discreet cough of approval, would be superfluous. Gradually, he was coaxed towards performance. The response, when it came, lasted twenty minutes. More. Much more as he motored on, between teasing and fecund hesitations. There would never be a second question from Wright. Keiller had the book in his head. No drama, no special emphases. No corpsing to signal the carefully weighted humour. The technician couldn't be sure where this had begun and when, if ever, it would end.

That night, back in the studio, this dialogue around which a programme had been built, vanished. Two minutes before they went on air. A new digital system had been brought in. Perfect quality, stereophonic truth at the flick of a switch. But Keiller's extraordinary flight of language was too much. The system crashed. The echoes returned to Arnold Circus, where they can still, if you stand long enough, be tapped.

The Roebuck of Durward Street

So much can be said when the walls are left
standing, revealed at last, the secret
no longer worth the keeping, old medicine-man
enlightened, suspicious of a son holding down
the mortem of history – dust
instead of air. Cancel the stench of
the leashed dog, brute circumference, apron & spike
no ice in the bucket, no purple heel from which to sip . . .
The site is a film of powdered stone
brought swiftly to ground,
a gesture of mindful erasure.
Bones dance against a sunlit wall,
their crime is longer than their life . . .
shadows driven underground,
reservoir of drowned voices.
The beast trapped in the thicket is
still curious about the split prism, the star-
burst newsflash of the hunter's rifle.

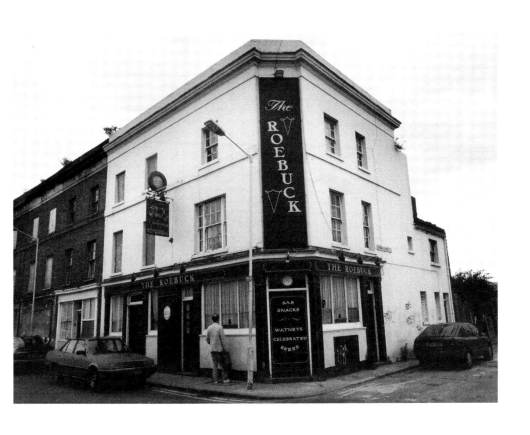

Drif and Martin Stone

Martin Stone hopped, pre-dawn, through the Cheshire Street market, scavenging books. Winkle-pickers, tourniquet trousers, mildewed beret, bulging swagbag: Blind Pew impersonated by Max Wall. Cork-tipped fag grafted to trembling, prehensile fingers, he was an anthology of retro-fashion. And in his wake there eddied a whirlwind of gossip and, amazingly, good will. The stall-holders, having been dispossessed of their choicest treasures, reminisced so wistfully about him that he was granted a prematurely posthumous status. His regular disappearances were eagerly anticipated; nobody speaking to him could believe he was actually *there*. Conversations were post-synchronized. If I revisit Ron with his cargo of competitively priced publishers' 'seconds', the first thing he'll say is: 'Any news of Martin? Lovely feller.' (By contrast, a baseball bat waits under the green baize table for the advent of Drif, Martin's rival book-runner and spiritual contrary.)

Drif and Stone, the yin and yang of it. The cavalier and the square-head. Sacred monsters, both. One with the Alcatraz fuzz (incubating his own execution), and the other, white-skulled, tonsured like a black-orgy monk. You can hear Drif's bulldog teeth grind if I call Martin 'the guv'nor'. (Hard-bitten Californian dealers rave about Stone's 'eye', his impeccable taste, even as they return to find the books they've paid (cashmoney) for, a year before, still stashed, exactly where they left them, in a dusty corner of Cannon Street Road.)

Drif's mistake was to go public, to start believing his own fictitious and brutally edited cv (the truth was both stranger and more mundane; painful, human and perverse). He enjoyed his sun-ray instant of exposure as the obituarist to the book trade. A barking eccentric who had outed himself in a Tourette's-syndrome rush of bad puns and genially delivered vitriol by way of the appallingly printed pages of *Drif's Guide*, a yomp through the hellish circles of British provincial life: book pits on a permanent lunch-hour, vegetarian

troughs, bicycles wrestled onto trains, transvestite dealers, petty crooks, junkies, anoraks and Stalinist bedsits where he could lie awake staring at the ceiling and listening to the World Service, while the landlady and other victims hammered at his plywood door. His book, the first time round, was a minor masterpiece. A fabulous stunt that he insisted on repeating, until its charm and originality became the party tricks of an indulged child. After the *Guardian* profiles and the radio spots, there is no choice: cash in your temporary fame for a one-off novel or vanish forever

Drif produced the novel. (Stone was cannier. He inspired fictions. He punted at mythical immortality, but let some other bugger do the work. 'For all those other old farts of musicians who, as Martin Stone reports, nowadays jump out of the bus and head for the nearest second-hand bookshop . . .' reads the dedication to Michael Moorcock's *Elric at the End of Time*. Emanuel Litvinoff began his first novel, *The Lost Europeans*, with a chilling prophecy: 'Coming back was worse, much worse, than Martin Stone had anticipated. When he got into the boat train at Liverpool Street, with English news-papers and periodicals stuffed under his arm, the usual drizzle falling from the grimy London sky, he'd told himself this was just a business trip . . .' But Martin's return was carrying him *away* from London; home was elsewhere. For Stone, like Derek Raymond, the exile began in Paris, where, by going back to the street as a musician, escaping the conditioned reflexes of his London life, he could once again become what he truly was. An absence. A conversational prompt in places where dead reputations are talked up between deals. Nights under strip-lighting. Cold coffee and hot stock. Dark glasses steamed up by kettles, kept on the boil, to lift library labels from future first editions.)

For Drif, licking his pencil, attempting the tortuous feat of self-ventriloquism, the novel was a suicide note. The first draft, which I saw, was remarkable, an epic of Nabokovian obsession as narrated by Richard Allen, author of the NEL *Skinhead* pulps. The typescript was so driven and peculiar that it was in grave danger of finding a publisher – until Drif called it in and extended the weakest element, the nakedly transcribed letters, to monumental length. When the literary agents blew cold, Drif vanished. Definitively. He had become his book.

Driving these boys around the map, I picked up, without trying, enough material to let them dictate my first novel, *White Chappell, Scarlet Tracings*. Their lives were failed auditions: Martin, the guitarist with too much talent for those other (Rolling) Stones, had watched with amusement as snotty kids with permanent colds plagiarized his riffs. Drif busked his encore, louder and louder, to cover for the absence of applause. He was a misunderstood autodidact with the dress sense of a golfer on a P. G. Wodehouse dustwrapper. Stone was exquisitely mannered, a model of courtesy as he picked your pocket. The paranoid fugues were seasonal and soon forgotten. Rubber cheques that proved difficult to unroll, single items variously sold to a dozen customers: all was forgiven. He was ageless, a stalk-legged Second-Dynasty juvenile. He dissolved into smoke as you listened to him.

Heroes to their chauffeur, this pair were cast as villains by plenty of others – stiff-necked creditors, innocents who thought an IOU was something more substantial than a fake autograph. Being, for most of my adult life, of fixed abode, my sole function where they were concerned was to audit telephone calls: 'I have absolutely no idea where Martin/Drif is at present. He was glimpsed in Charing Cross Road/Brick Lane/Portobello sometime in the last six months. Failing that, try Yellow Pages.'

I ran Martin everywhere: Holland, Belgium, France – unsentimental excursions through cellars and backrooms, eating on the move, mustard dripping from frankfurters, lines of white powder snorted from the top of a battered black case. I learned about the alternate canon, the secret heroes: M. P. Shiel and William Hope Hodgson, Uranian poets, Sexton Blake pulps penned by Flann O'Brien, shilling shockers, David Goodis and William Irish, *Dope-Darling* by Leda Burke (a.k.a. David Garnett). Martin was the occult historian of the book trade. The shape-shifting Shadow. I pictured him rifling through Oscar Wilde's scattered library, punting forged Chatterton forgeries, conspiring with Michael Moorcock to 'discover' unpublished tales by Arthur Machen. Even on trains, pricing up the stock before hitting town, he would run into old acquaintances like Elvis Costello (who was rumoured to collect nothing but multiple copies of *A Clockwork Orange*).

Once Martin talked me into writing off a distressed motor in a madcap dash to Bordeaux. He'd had a preview of a catalogue,

mouth-watering first editions of Virginia Woolf, unimpeachable rarities. We had to beat the pack: away, at close of trade, from Camden Passage and straight out on the road, toothpicks propping up our eyelids. The advance phone calls from sawdust bars were all bad lines. But we made it, steam hissing from a punctured radiator, eyes yellow as bad liver, heart pounding like a cat in a pillow-case. One sad table of Book Club editions, John Masters to Iris Murdoch. 'No problem,' Martin said, 'we'll hit the Channel Islands.'

Give him his due, it worked out pretty well – after the strip-search (Martin had mislaid a baseball-sized chunk of resin) and the Prevention of Terrorism forms. Jersey was a time-warp: shopping malls of apartheid tat, brandy, cigars, perfume, hard-faced suits whose tattooed minders hefted carrier bags of dirty money, all backed by miraculous books, sacks of them. Ford Madox Ford novels from the First War still in pristine jackets. The only extant copy of Mark Benney's *The Scapegoat Dances* in near-fine dust-wrapper. Stone filled a cardboard box that had once wrapped a deepfreeze unit and blagged it onto the plane as hand-luggage. Take away the expenses, fines, terminated Austin Maxi and we almost broke even.

The day-for-night lifestyle, speed-as-tranquillizer, began to tell: stomach ulcers, justified paranoia. Martin tried a shop. It was conveniently situated near King's Cross station and open only in the small hours, so that he could call in to exchange suitcases. This was taking commercial modesty to extremes, but that was the nature of the man. It wasn't until he pounced on a Mighty Baby LP ('Britain's answer to the Grateful Dead') that I learned of his legendary past. 'One of the two great guitarists of his era,' babbled rock archivist and Tennyson scholar Doc Hinton. 'Makes Clapton look boring and provincial.' I excavated Stone's genealogy: The Action, Savoy Brown Blues Band, Stone's Masonry, Almost Presley. Whenever success threatened, Martin made his excuses and left. 'The game,' he would admit, passing through town, 'has been annulled.'

It had to be exile, Paris. Elective bohemia with Père Lachaise on his doorstep. He busked tourist cafés with a jug-band version of 'Heroes and Prophets', swamp music for booze money. But his most poignant role was as doppelgänger for another reinvented spectre, Derek Raymond (the former Robin Cook). In neighbourhood bars,

Martin accepted cognacs intended for Cookie and graciously made his mark on the proffered Gallimard paperback. 'Salud!'

When the two notorious berets finally met, they drank the complimentary bar of the City Airport, Silvertown, dry. On quacks' orders, they were both teetotal at the time and making do with iron-enriched pints of Guinness. Cook soliloquized on mortality – the 'general contract', as he called it – and Stone (like Ben Johnson in *The Last Picture Show*) lamented the passing of the runner, the old-time grubber, the bookman who knew the difference between John Locke and George (the Tooting interplanetary).

Stone, the conduit of urban memory, survived, flourished. He became one of the New Europeans, shuttling through the Tunnel. Hitting the mother lode on both sides of the Channel. Cataloguing rarities, inspecting provincial libraries, facilitating deals. It was the substantial vegan, the ruddy-cheeked bicyclist Drif, with his terrible cargo of facts and deranged theories, the man who knew something about everything, who disappeared. He'd gone walkabout, for weeks at a time (until the heat was off), but he had always, previously, bounced back. There were phone calls from remote highland platforms. Not any more. Unconfirmed sightings spoke of a similar-looking but much thinner man, ghosting through his old haunts without the enthusiasm to demand a discount. His hair was longer. The clothes less flamboyant. Martin had abandoned the beret for another range of headgear. Perhaps Drif would pick it up. The cycle would be complete, and the contraries would fuse into some devastating amalgam.

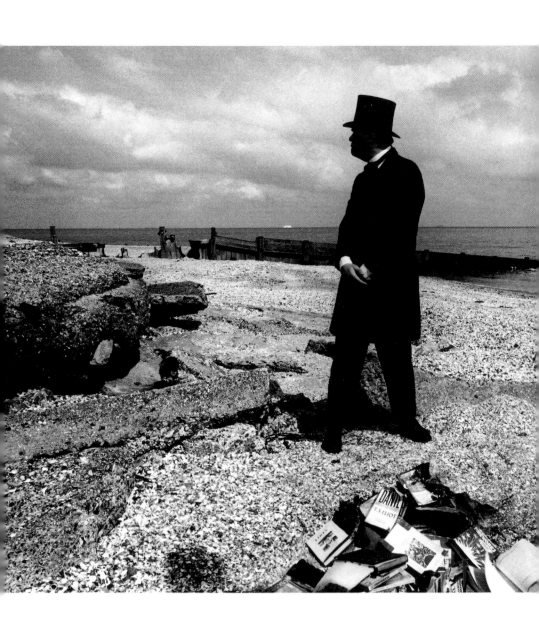

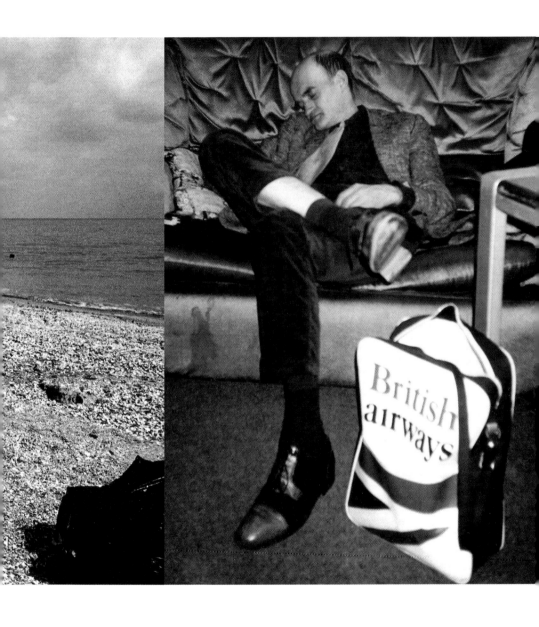

Where the talent is

i.m. Derek Raymond

sweating bread:
Colombian coffee fires the tongue as the date
on the cheap watch clicks a lunch-hour thirst
pushing the scribe towards hard-earned
amnesiac seizure: keys
hot as the thought of hell, fever beads
we send for Polaroids to confirm our loss

the angel in the cemetery avenue
overreaches herself lacks sap in the vein,
Herne horns of living ash better far to
visit this place than to have it described

3.viii.94

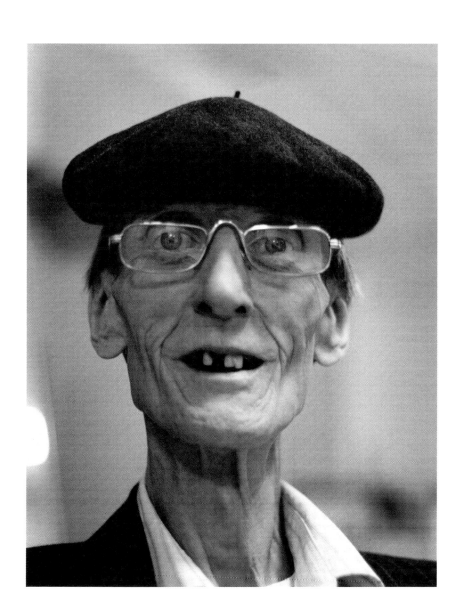

Re-immigration experienced for the first time

Susan Bell midwifed the best-looking edition of any of my commercially published books: the American *Downriver*. Naturally, the text had been somewhat bowdlerized. I'd laboured on an introduction that was supposed to clarify a narrative that wasn't there. (Then had it topped and tailed.) Susan retired from her job (like too many of my editors, bulleted or pensioned off) as soon as the book was published. It sank without a trace. But her presentation (exactly what I had imagined) of the Conradian postcards, the rivers, slaves, executions, was faultless.

Marc's record of a trip I took, a return to Tilbury and Gravesend (by way of Gavin Jones's studio and Marc's Heneage Street room), brings back a day when Susan was, in effect, walked through the novel. It was retold before it happened. And, in looking at those photographs, I remember the sense of immigration that Susan carried with her, the courage. One portrait in particular, at the water's edge. That headscarf. The rope and the hook. Ready to cross the ocean, to engage with the frenzied possibilities of America. She was the element that was missing from my story. It's a heart-stopping image (the way those hands are clasped, the stray loop of hair). Fiction imposes itself on pure documentation. Late afternoon light relieves the darkness of the river. This was the furthest point from London where its gravity still pulls. Susan was making an important decision. There was nothing in my novel that could do what this photograph did.

I left Susan on the platform at Devons Road. She was struggling with a couple of Marc's prints and a Gavin Jones painting. Launched for an impossible return; the elements gathered, so that she could escape from this troubled passage of life.

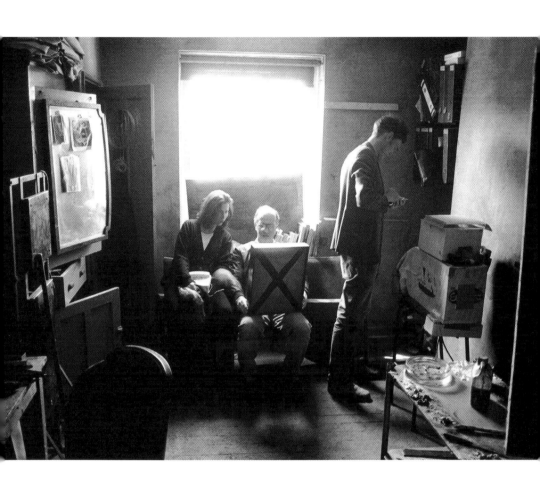

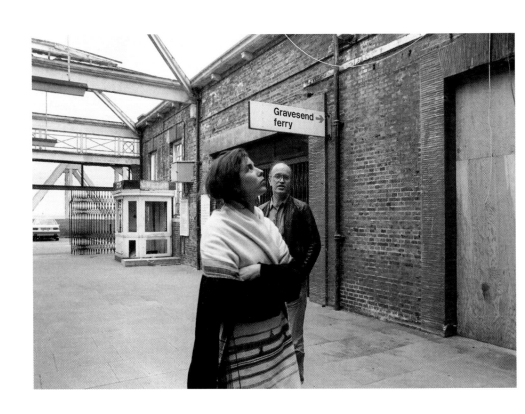

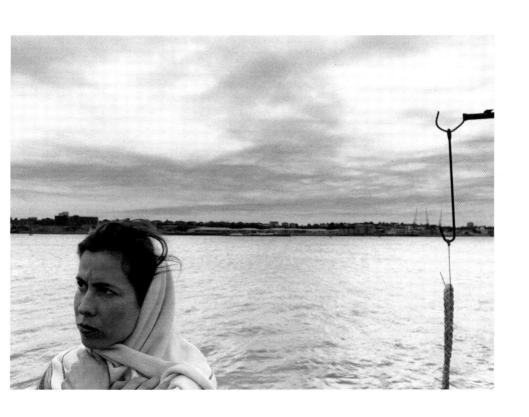

Exile

David Gascoyne had, years before J. G. Ballard, a sense of the upriver suburbs that owed everything to an engagement with Surrealism. (His sympathy was innate. He knew what strange shapes lay under the mantle of rigidly enforced English conformity long before he made his first trip to Paris.) Living at his parents' house in Twicken-ham, he recognized the visionary potential in documenting the short bus trip to the library or the train excursion, out of hours, into town. Aged 17 he produced his only novel, *Opening Day*, a camera-eye sequence of tracking shots across the mundane, the sublimely ordinary surfaces of lost time. (All that was then available to him.)

The benign prison of parental control gave way to periods of London wandering; Gascoyne was a natural psycho-geographer, tracking the heat spores of Rimbaud, from the British Museum to Wapping and Limehouse. He met and corresponded with the great ones. Voice located him. He moved restlessly between cities and places of patronage, privileged poverty.

After a long period of silence, from which he was guided by his wife, Judy, Gascoyne found himself back in that comfortable suburban module. The modest, pleasant house in a quiet street. Paperbacks in the bedroom. Sunbeams through leaf cover in the afternoon garden. The Isle of Wight is a sanctuary where gnosis is earthed; city spasms unwind, memory is provoked. It's like returning to the England of the '40s or '50s. It's all suburb, slow-moving, well-behaved traffic, bungalows concealing mysterious narratives. We arrive, like bailiffs, to recover the golden light that David had secreted in his wanderings. To taste Twickenham and places we had never succeeded in reaching on any of our excursions.

The synagogue

Marc's framing rightly positions my collaboration with Rachel Lichtenstein, *Rodinsky's Room*, as cabbalistic theatre. Our task had been to mediate the disappearance of a hermit/scholar from the attic of this building. By this intrusion, we had become implicated, in very different ways, in the mystery. Our interrogator, earphone like a hammer against the head, finds that his left arm has turned into ectoplasm. What are we straining to hear? Nobody is there; not at the east end of the long room, the cupboard where the holy scrolls were kept. The click of the camera behind the technician's back imposes itself on the tape of voices. Rachel, heavily pregnant, becomes a Francis Bacon portrait. Paint combed with a razor. I am two-faced, explaining and performing. A pair of spectacles on the empty chair beside me. I remember the chill of finding David Rodinsky's name written inside a spectacle-case in the cluttered attic. There's nothing here that resists explanation. The licorice pillar. The grille. Superfluous, half-cancelled human presences on their way into the dark.

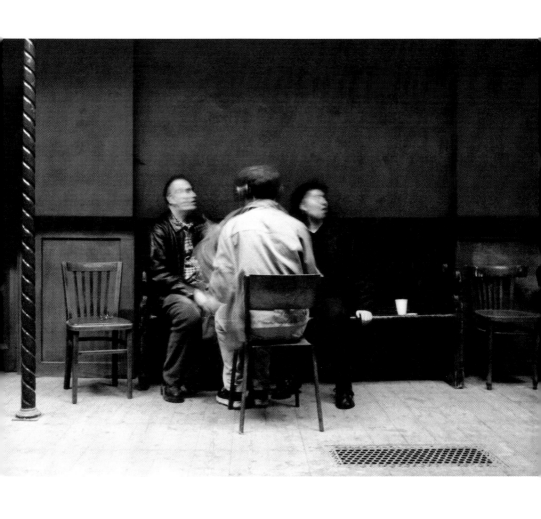

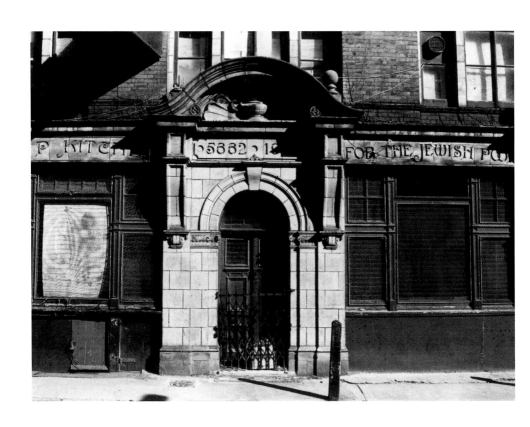

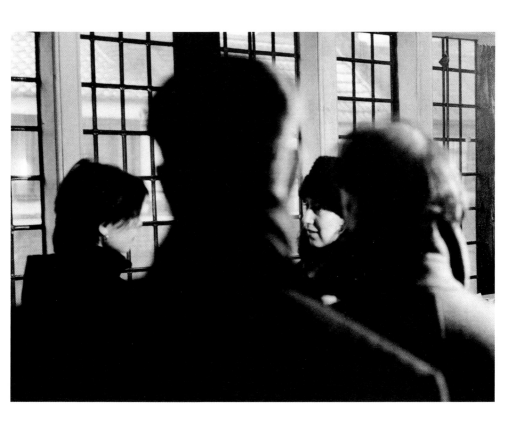

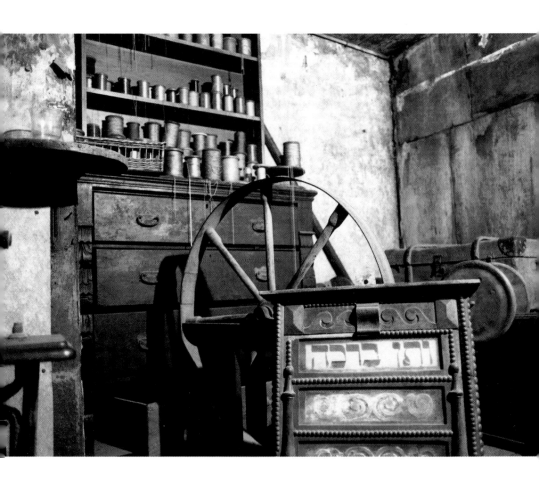

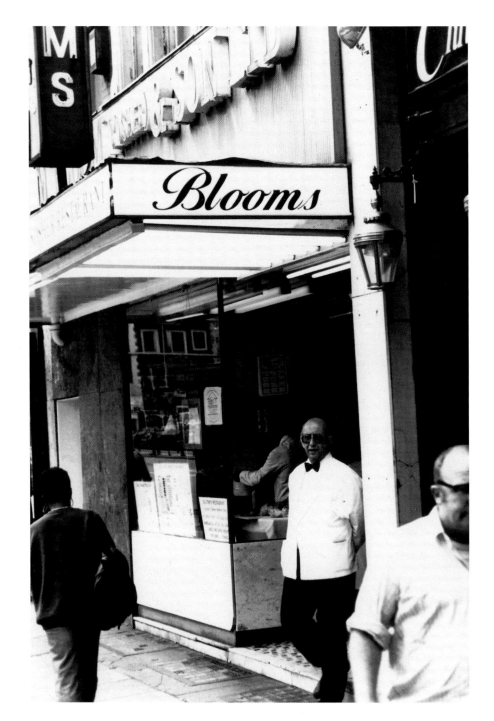

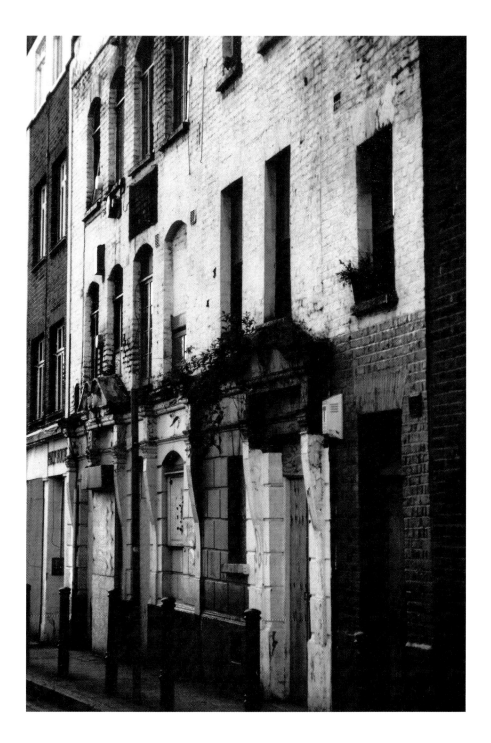

Kathy Acker & *The Falconer*

Kathy Acker was never quite there. She was always on the point of leaving, crossing the Atlantic, changing publishers, moving houses. She couldn't, on occasion, have been more *visible*: at readings, at performances, gossiping at the till in Compendium Bookshop, Camden Town. There was the warmth of her greeting, touch; a small, fiercely luxurious creature looking up with blinking eyes. A customized Jewish-Princess alien. But this was not her. Not Acker. This contrived, post-Punk artefact – expensive leathers, rings, lightly sculpted scalp, enough tattoos to provoke a dozen Peter Greenaway films – was an inhabited hologram. So much in your face that you couldn't see it. The other stuff that was going on. The swift synapses. The compulsion to write. Justify. Understand. Take revenge. Achieve an impossible balance between the nightmare of existence and a vision of Eden. Her own polymorphically perverse pirate paradise. The island of bad fathers, heroic self-mutilating daughters; a generically inspired nowhere of shape-shifting texts and orgiastic release.

In London, she talked about New York, perpetually disappointed in her search for a 'scene'. Different energies. She played back the loops of imagery that cast her as a granddaughter of the vulture-faced elders of Beat. (It was a way of confirming her role, defining herself to a generation without memory. A culture that had no use for names such as John Wieners, Jack Spicer, Philip Lamantia.) She recalled driving around Lawrence, Kansas, at dusk, in a vehicle that was somewhere between an ambulance and a camper van, acting as bait for William Burroughs, hooking campus athletes and high-school junkies for undescribed sessions of blood-letting and psychic vampirism. She yarned, with affectionate resignation, about the time Gregory Corso had tipped her, penniless, out of a moving car in a Black Panther-controlled zone of Oakland, California, when she declined to feature in a midnight threesome. These stories, punctuated by immaculately timed pauses, exclamations, tosses of the head,

157

had been 'treated' in the same way as her fiction. They were performance texts, in which truth can only be achieved by unfettered leaps of imagination.

Acker had an instinct for arriving at the moment when she was most needed. She took on, and gloried in, the role of girl-in-the-boys'-gang: first, among the gentlemen's club of senior Beats, and then in the London counterculture. She was always making up the numbers with Alan Moore, Bill Drummond, Stewart Home. The performance she gave, in a little-girl outfit (to soft and lethal vocal rhythms), at an event known as *Subversion in the Street of Shame*, made me think that she would have the narrative voice we needed for *The Falconer*. (This was a film I was making with Chris Petit. We had a strong physical presence, a young woman who had trained as a circus acrobat, playing one of the lead roles – as the elective daughter of a messianic con-man father. The trouble was that the girl's voice could scarcely be heard. Its whispering modesty contradicted the resolute power with which she moved. Kathy would provide the missing sound: the articulation of a dangerous intelligence.

The early draft of the narrative I'd written was influenced by Kathy. This was a mistake. When she came to the editing suite to do the reading, she delivered a performance of herself, giving a florid account of my take on her take. It was too deterministic, too pointed. The script inflated into hysterical opera. Kathy's maturity, her knowingness, obliterated the images she should have been animating. She was a more-than-Acker instead of the tentative consciousness stream of a person who had never existed. (Kathy's was one of five voices we tried before we got it right: with a girl working in the next office, someone who had hovered interestingly in the doorway, as much repelled by Peter Whitehead's story as prepared to involve herself in it.)

But Kathy had met Whitehead at the time of the *Street of Shame* event. She loved the film and wanted to be part of it. We chatted for a few minutes. I explained the drift of the thing and then she launched directly into an improvised performance that became an important element of the finished story. She talked to Françoise Lacroix, who played the young woman, warning her against Whitehead, against fathers. There was no preparation, no rehearsal, no special lighting. This was Acker as her own fetch, a double of

herself (author of *Hannibal Lecter, My Father*), speaking quietly to a girl (with no voice); a twin whose special achievement was to remain radiantly blank. To express nothing. So that Acker's riff, playing across the floating images on a set of monitors, was returned like a mantic echo. This cameo must have been the last time she appeared on tape. It would be too easy to gift what she said with prophetic resonance; that would be sentimental and false. But one of the shamans she was consulting spoke of 'a black spider' wrapped around her heart. A spider of language which she now offered to Françoise:

> If you think of him [Whitehead] as a bird, a bird which spreads its wings and can fly, he presents that kind of power. It's a very sexual power. In the society in which we live, we don't feel that we have power over ourselves, being women. In order to get power, self-power, to do what we want, we need to glom on to a man, a father. There's something very black about Peter in all this, something black because it's so narcissistic . . . Everything is sexual. He's drawing you in. And you're going to end up in a space that's black, with absolutely no power. That's what I'm worried about.

I saw Kathy two or three times after this, in a pub on the canal, or in her rather gloomy basement flat in Islington. We were supposed to be working on an interview, planning a future collaboration, but most of the time it was chat, gossip. She wanted somebody to clear boxes of her books. She was moving again, selling up, returning to California. She wasn't well. She'd lost the energy she'd had at the time of the *Falconer* performance. But it was temporary, bad water. A bottle dropped into the canal. That was her justification. That's why the herb teas, the spiritual disciplines, the healers, weren't working. She took so many pills, she rattled. I'm sure she was right. It was the place that was wrong. The darkness of that water, its history. That was her way of making the fabulous real, taking and transforming the mundane until it achieved an unchallenged finality.

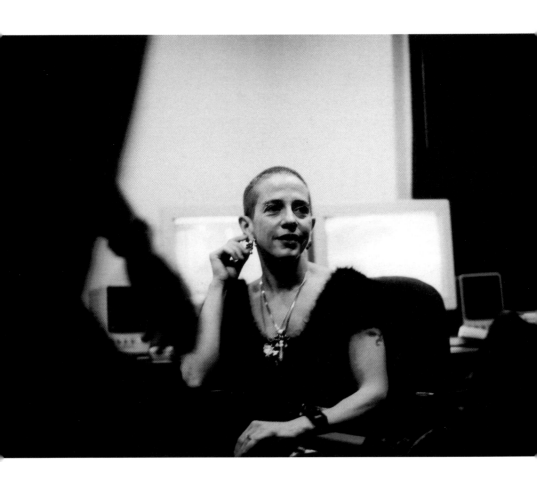

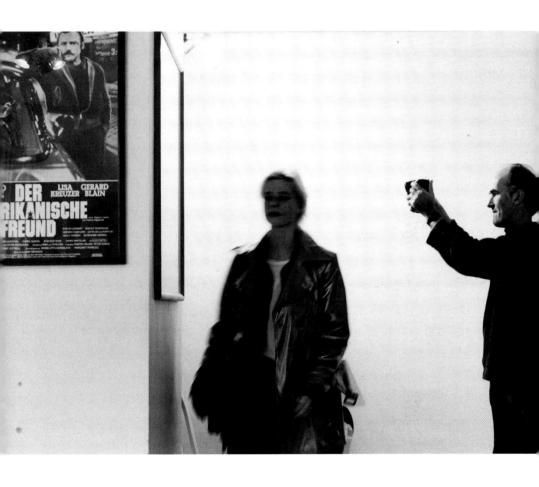

Ackroyd and Moorcock

I came across Peter Ackroyd for the first time at the old Poetry Society in Earl's Court Square. This was before he'd started on the novels. He was reading (with a nicely managed lisp) wafers of cleverly doctored prose, lyric bits. Bright and jaunty and cosmopolitan, imported New York eavesdroppings. Now, a successful man of letters, he'd been persuaded, against his better judgement, to meet his West London colleague, Michael Moorcock . . . at a poetry reading.

It was in Notting Hill, a momentarily active gallery that soon vanished. Marc Atkins was there, manoeuvring himself to get the shot of Eric Mottram manifesting in front of a flamboyant oil painting, a nude. Moorcock was slumped in the back row, chin resting on the handle of his walking stick, paying his dues to an extinguished culture, still suffering over that business with losing track of Denise Riley's name and achievements, when introducing her at the Albert Hall. This gig was an endurable penance, on the promise of a night out with Ackroyd. Between them, for five or ten years, they'd kept the London novel afloat. Story-tellers who didn't need to dispute the bones of the city. Ackroyd was frighteningly fast. He could fillet a library in a couple of hours, knock out a novel before he rolled out of bed. Then come back from the gym to compose (in one take) a lead review and make notes for the next monumental biography. But Moorcock had started earlier, pretty much in short trousers, editing Kit Carson comics and Tarzan adventures. His bibliography ran to well over a hundred titles: genre, comic strip, picaresque, fabulous, scholarly, off-the-cuff, recycled, parodic, possessed by Stevenson, the two Georges, Moore and Meredith (whom nobody else had read in decades); neo-Victorian epics that were anguished and elevated by memory. He'd typed books in three days (when he was off-colour) and exploited all the Grub Street tricks with cleverly contrived white spaces and compositions that burst forth (like the serialist, Charles Dickens) in sixteen-page clusters. In his pomp, he

tapped directly into the genius of Europe: rhythms, sentence constructions, submerged quotations, landscapes ('Don't worry, Mr Cornelius, you're fixed up destinywise. Drift, drift . . .'). The voice of the narrator, Pyat or Mrs Cornelius (a spirit as wise and generous as Angela Carter), was the voice of place, seductive, wheezy with smoke and gloriously untrustworthy. These books, interlocking mythologies from Moorcock's 'multiverse', were anathema to those pedants who wanted to deal in facts, Calvinist certainties, punishment and reward.

Ackroyd breezed in, after feeling his way along the gallery window for a secret door, just in time to catch Jeff Nuttall as he boomed towards climax. Spiralling, gravy-stained metaphors, sticky fluids, secretions, orgasmic surges of breath from the ripe and practised actor/performer. 'Oh god,' Ackroyd moaned, head in hands. *Mal de mer*. 'One more "fuck" and I'm out of here.'

Moorcock talking, gesturing with his stick, Ackroyd scampering with short, fast strides to put the horror of the reading behind him: they scuttled around the corner into an Italian bistro. It was cramped, loud. Moorcock suffered from smoke. His eyes watered. Ackroyd from not smoking. He pulled out a legal document. It was his latest will. His long-term partner had recently died. He wanted Moorcock and me, since we weren't beneficiaries – we wouldn't be inheriting a paperback – to witness the document. Somewhere after the third or fourth bottle – it was a slow night by Ackroyd's standards – the will slid off the table and floated away across the restaurant. Tangles of legs, waiters invited to dive after it. Nobody knew who they were, these urban magicians. The will was smeared with spaghetti sauce, footprints, cigarette ash. It would probably surface, years later, in a frame by the cash register. Next to a signed snapshot of Damien Hirst.

The rest of the evening was an eccentric progress. Ackroyd was bounced down the stairs after trying to infiltrate a private party. Moorcock was still reminiscing when I slid from an unforgivingly German chair in Peter's austere flat, outstared by William Blake's death mask.

On another, tamer occasion, Marc Atkins was around, with his camera, travelling back from Camden Town, with Moorcock in the taxi, in the general direction of temporary digs in Tufnell Park. I

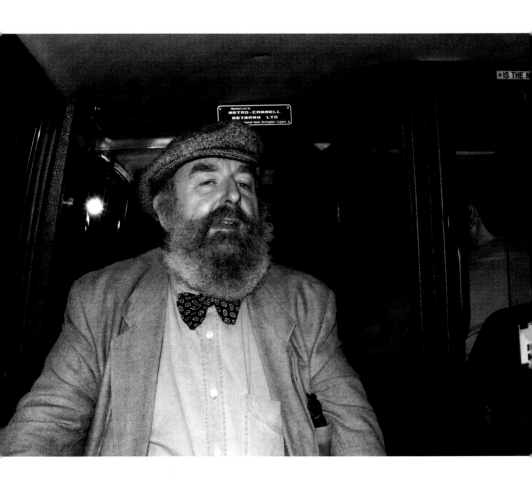

thought of Atkins's photograph when I saw a doctored map of this district in Moorcock's study in Bastrop, Texas. Now he was one of the disappeared. Ackroyd had moved to Islington and was knocking about with Frankie Fraser. Moorcock was so far out of it that he seemed to have been placed in a Witness Protection Programme. Like William Burroughs in Lawrence, Kansas, he waited on a quiet street, in the middle of nowhere, with his cats for company; waited for the day when two strangers in dark suits would roll into town. To provide him with that missing sentence. To put a cover over his

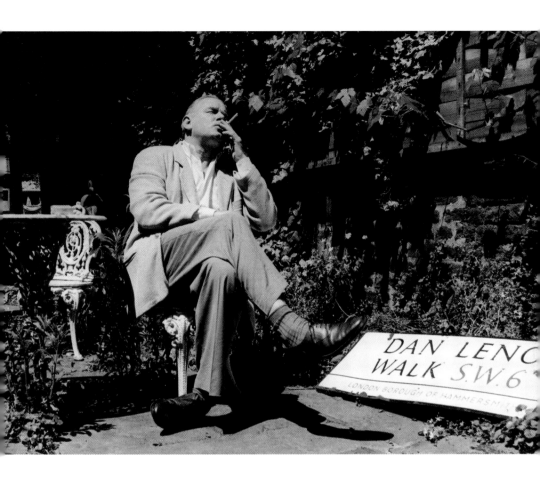

word processor. Take away all those frantic sheets of text. Moorcock sat there, in exile, in his cabinet of curiosities, with his William Morris fabric wallpaper, his Arts-and-Crafts furniture, his library of three-deckers, his Pierrots and lead soldiers, his playbills, magazines, platinum disks, Sexton Blake back numbers, carnival masks, his pistol. He listened to the melancholy hoot of the train, the neighbours' guard dogs, the broadcast babble from the high-school football stadium. London remembered. On his screen the title of his uncompleted novel twisted and turned, like fish in a tank: *King of the City*.

London stone

The point about London Stone is that while everyone agrees it is significant, nobody knows why. Some call it a Roman milestone. Camden, according to S. Foster Damon, 'believed it was the central miliarium, from which the British high roads radiated'. It can seem massive, sculptural (as photographed by Marc Atkins), or papery and ephemeral, according to the play of light. It has been captured, that much is certain. Set in a tank. Hidden and exhibited.

There's no mystery about where to find it. The Stone is name-checked in Patrick Keiller's *London*. And anybody who wants to can examine it beneath the pavement, in the offices of the Overseas Chinese Banking Corporation in Cannon Street.

The new alignment hurts. It's part of a process whereby all the ritual markers of the original city have been shifted, not by much, by just enough to do damage; to call up petty whirlwinds, small vortices of bad faith.

Stone as meat, that's what Atkins sees. A liverish lump, pock'd, worn to fibre, then turned, on the curse, to rock. Blake's mythology took London Stone (twinned with Stonehenge) as his still point from which to move the world: by sacrifice and force of will. Break the glass, strike the stone. If it is to be treated as a trophy from a colonial war, encased like a fire extinguisher, it will demand justice. Light from the narrow rectangle of the window exposes the fossil record, worries at the fault lines that must one day split, recalling, on the instant, all the journeys made from this place.

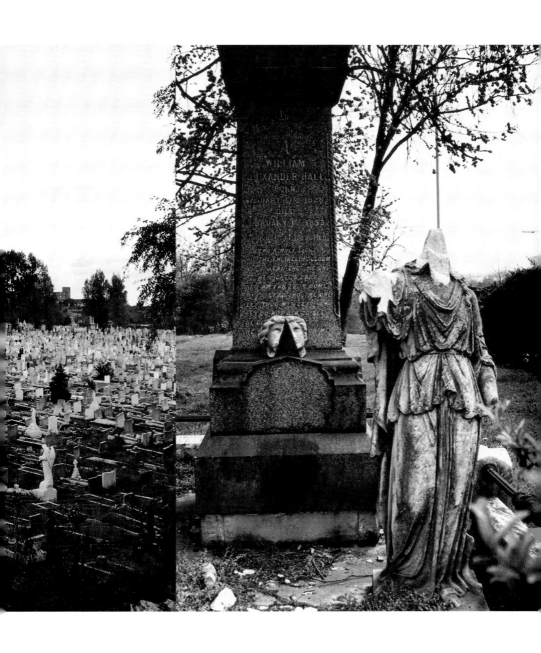

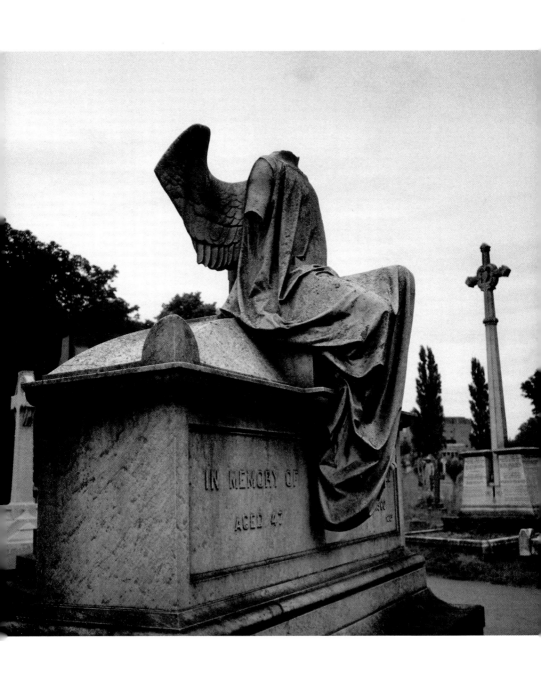

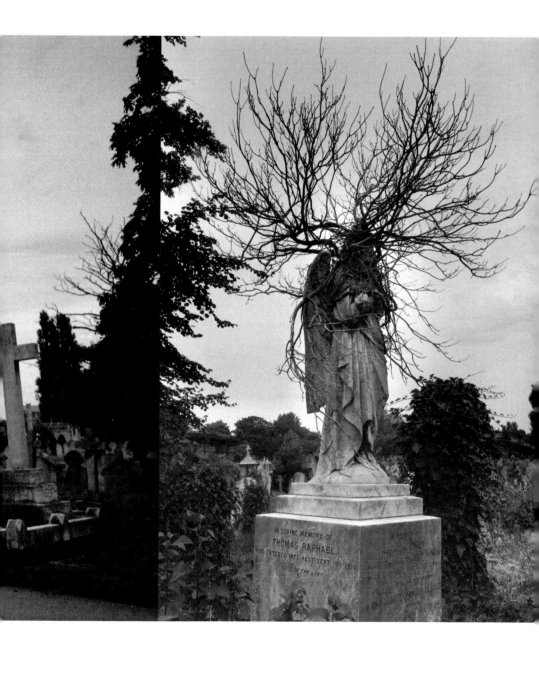

The vegetative Bunyan

Marc's photograph of the John Bunyan effigy in Bunhill Fields captured something I had niggled at for years but never successfully transmuted. (Bunyan, they tell me, isn't there. This is just a pious memorial, an alignment with the other great nonconformists, William Blake and Daniel Defoe.) As ever, Marc caught the moment – before the sleeping figure was restored. He saw the vegetable god, the albino sacrifice: lichen instead of nose-hair, black fur emphasizing the cheekbones. The spirit of the traveller, the tinker, was breaking out of its mummy case: the powder-grey *Illuminatus* whose cracked skull leaked light over the dark burial ground, over the Cromwells and other exiles, banished beyond the city walls, planted here where their venom could be contained. Bunyan is the figure of transformation. Marc had to clamber onto the tomb, defile it, to achieve this instant of tranquillity. A floating head. Watching him, standing off, I felt my back go into spasm. It was the beginning of the end of that cycle of walks. There is a price to pay for freezing that which should be allowed to remain immanent.

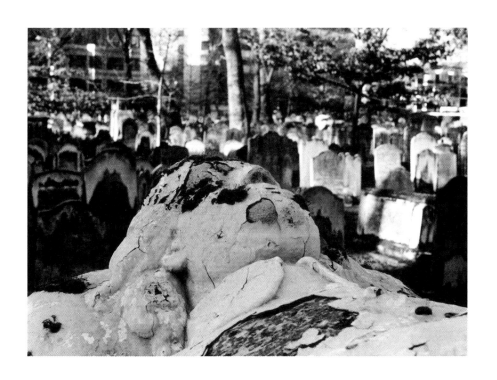

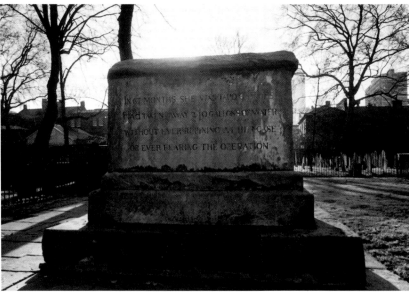

The warehouse on Durward Street

A survivor. Overseeing, to the north, the doorway where the first victim of Jack the Ripper was found, the demolished flats with their open-air chapel, the Jews' Burial Ground. And, on the south side, the labyrinth of the Underground and the Royal London Hospital. A black lacuna noticed by Finnish film-maker Aki Kaurismäki as a suitable location for *I Hired a Contract Killer*. It had been coveted years before by the Uppingham entrepreneur, gallery-owner and publisher Mike Goldmark, when he was being treated to the Whitechapel tour. Enquiries came to nothing.

The building was pre-fictional, expressionist. It solicited – and, at the same time, repudiated – narrative. Characters in my novels were always being sucked into its shadows, but they never succeeded in penetrating its interior spaces. I photographed it repeatedly, often with B. Catling lurking somewhere on the edge of the frame, as he made his way to the Roebuck.

I realized at last, now that the building had been colonized by developers, that it had always been one of the stumbling-blocks. A barrier. A displacement. It represented what wasn't there. Pass it and you shift from one zone to another, you exchange systems of time. It's the double of the stone tank, dark water, in Bunhill Fields: the monument to the woman who was repeatedly tap'd but who 'never repined'. It's a storehouse of memory, of pain. A reserve collection of urban nightmares, silent shrieks. The paradigm of a museum: one that is never visited.

Hardy's tree

Sharks' fins swirl and cluster around the tree: St Pancras Old Church. Where Thomas Hardy had been an architect's apprentice. A site later celebrated by Aidan Andrew Dun in his epic cycle, *Vale Royal*. The poet saw ghosts, willing himself towards a state of possession by earlier avatars: Shelley, Mary Shelley, Chatterton.

Anti-climb paint decorates the shoulders of my jacket as I follow Dun down the narrow alleyway towards the thermal print of the room Rimbaud shared with Verlaine in Royal College Street.

Marc Atkins formats darkness, paganism. The phallic stub of the tree with its cropped pubic rim. Slivers of night pressed between stones. Wave patterns. Razor shapes cutting the crinkled bark.

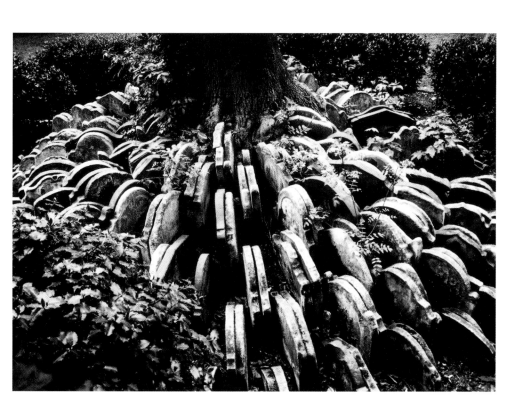

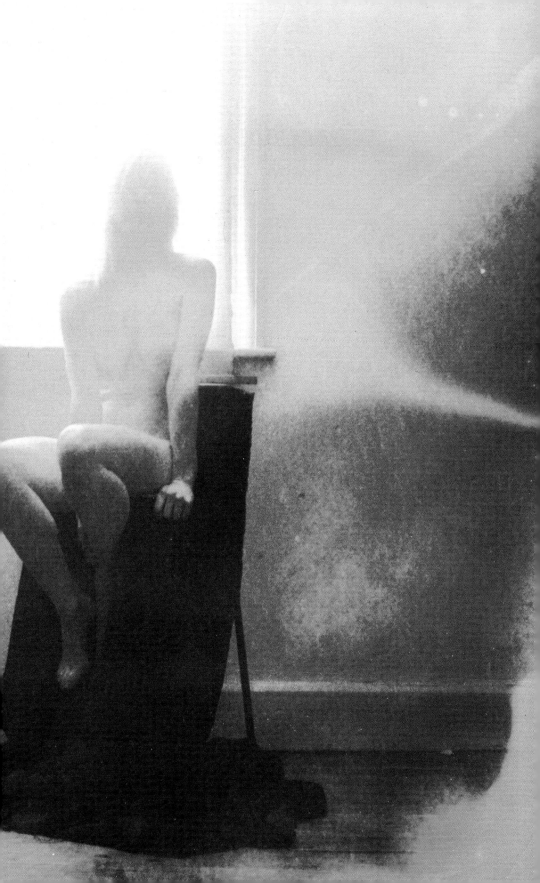

fracture *Rodinsky's Mirror*

Back at the start, at the beginning of all this, Marc's photographs were performances. He was *in* there. He was the subject (naked or disguised as an illuminated female figure). I tended to forget, with all the walks, all the cataloguing of London, the topography of the city, that the original images were made in a room with curtained windows. Yes, it was always about light – but much of that light, the element through which he worked, was imagined. It was conceptual light, borrowed light. Light worked, over and over, like a resistant sentence. I drew on the mystique of the photographer, the casual alchemist, for my fictions. I was fascinated by complex processes of transformation. I borrowed prints and stared at them for hours, allowing them to dictate the forward momentum of my narrative. Then, when all that dodgy art jabber was over, I'd take Atkins out into the purlieus, the margins, and show him sites that his locked-room conjurings had prophesied. There would be a fresh set of prints. Tautologous, but sometimes provocative. He would follow through on hints in the books, and attempt, for example, to make actual the metaphor of the triangulation from *Radon Daughters*. The best prints were so charged with sepia intensity, a blizzard of grain, that they couldn't be reproduced by industrial processes. They didn't 'read' as book jackets or illustrations.

One of the most haunting images from this period is titled *Rodinsky's Mirror*. The mirror came from the Princelet Street attic. Atkins hadn't taken it himself, but it lodged, for a time, in his studio. A potential prop that comes into its own when it is held out by his model. With the aid of a few scratches and a swirling soup of brown-gold light, the print sidesteps time and place and perfectly delineates a novel that will, now, never have to be written. The portrait, achieved by this sorcery, appears on the *back* of the mirror. It is another entity, unknown to subject and photographer.

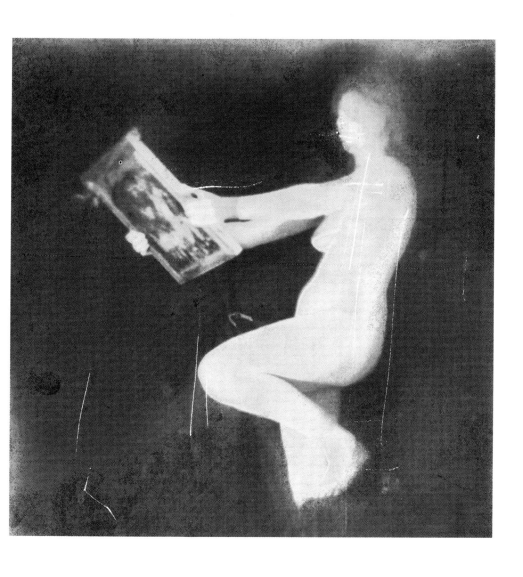

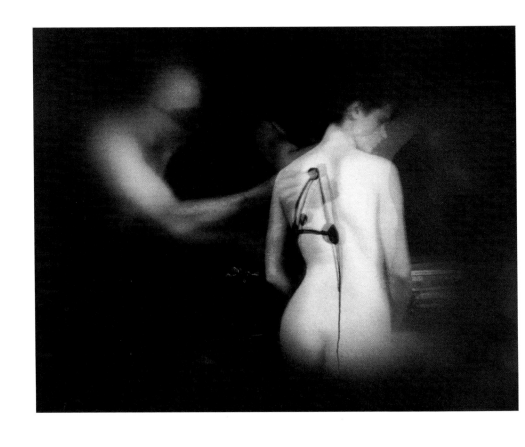

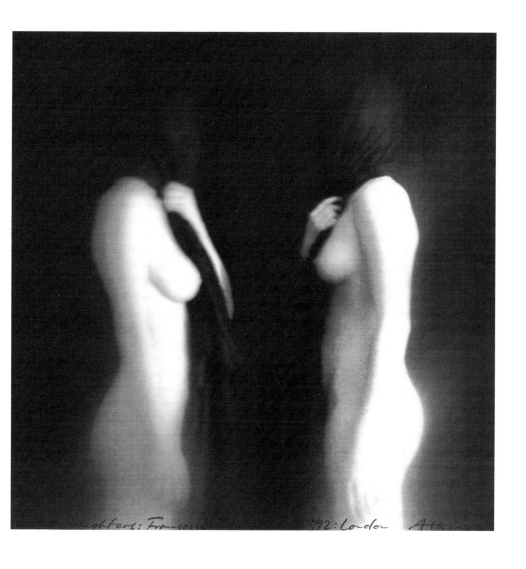

ghters: Franceur 392: London Atki

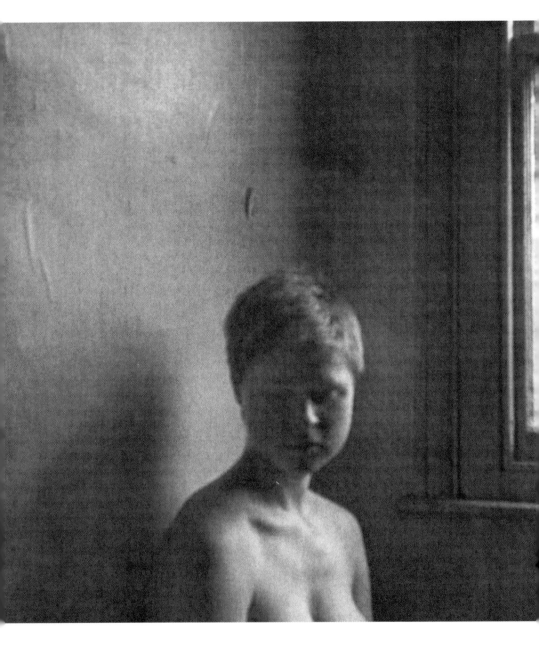

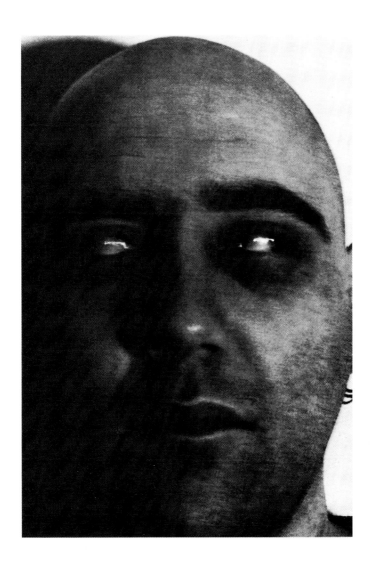

Gaudy living

Nice motor, John. A shiny-bright, nearly new Mazda in the light-splash of wintry Belsize Park. Broad pavements and respectful shops with their immigrant culture traces. John Healy, storyteller, author of *The Grass Arena*, ex-wino, vagrant, recidivist, boxer, has invited me for a meal at Chez Nous. (Sh-ez, he calls it. Like Chas not Shay.) Now, out in the air, he slips me a Christmas envelope, a nice little drink. From the inside pocket of his tasty overcoat. Success, when it hits, is to be shared. There's a film in the offing, loosely based on his only novel, *Streets Above Us*. The underclass underground. Customized retrievals (word-processed by a TV script doctor) from John's life as a dip, a handbag ferret working the Green Park-to-Victoria shuttle.

That's the moment, tearing open, with cold hands, John's envelope: the moment of fracture. The last time such a thing happened was in dubious, back-of-the-lorry slaughters out in Chobham Farm, Stratford East, in days of my own bourgeois-boho poverty. This street survivor is the only person, in plenty of years, who has picked his own pocket on my behalf.

Healy, as far as the publishing/promotional nexus was concerned, was a posthumous man who had the bad manners to stick around when the launch party was over. Every junkie/alky/killer/gonnif is allowed one book. *The Grass Arena* – with its sharp-elbowed picaresque, its lyrical Celtic interludes, its black humour – had been patronized with enough prizes. Why didn't Healy take his yellowing cuttings and fuck off back where he came from, into the jungle, into nighttown?

So began the second, and far worse, period of internal exile, ostracism and double-speak. The days of the blacklist after that little misunderstanding with the claw-hammer in his publisher's office. Now Healy had lost the communality of the wet brains and methsmen. The faces were gone and those that were left would make

short work of someone who had crossed the road. Drink dissolves time. Your day is defined by thirst. Darkness erases memory. A journey from Euston to Finsbury Park is an expedition to a foreign country. Shift a couple of postal districts and your biography is deleted. No future without a past.

Healy circuited between his mother's flat, off the Caledonian Road, and the chess cafés to the west. He found himself invited, as vagrant of the month, to liberal mansions at the top of Hampstead hill. 'Go on through,' they said to him. He was two courses into the banquet before anyone else came into the dining-room.

He was meditating, doing the exercises and writing. Stories, novels, screenplays. But nobody wanted to know. Where was the novelty? He'd had his pitch, his life was used up. Everybody remembered that wonderful film with Mark Rylance. The book was redundant. Rylance's impersonation was uncanny. He was more like Healy than John was. The thing that really disturbed them was this: if the man was alive and well, chipper as a cricket, cranking out novel after novel, then the emotion they had invested in the lowlife yarn was misplaced. An early death, coughing his guts up, was the least they could expect. The lack of gratitude in this creature was staggering. The reviews had been written under false pretences. The raves were disguised obituary notices.

Healy's books drifted out of print. The follow-up to *The Grass Arena*, the second act of a one-act life, went the rounds without a nibble. But now, through the lucky accident of the film, it could all come up camelhair. I watched the Mazda pull out into the mist. I'd have to go home to check Marc's photographs. There's one where I'm walking beside Healy. I was terrified that he would vanish into that fence. But, looking again, the way my head blended with the wood, I knew it wasn't Healy who would disappear.

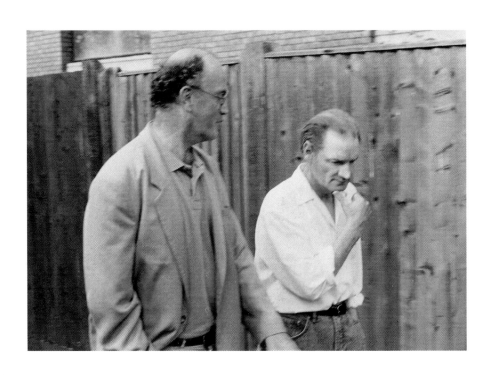

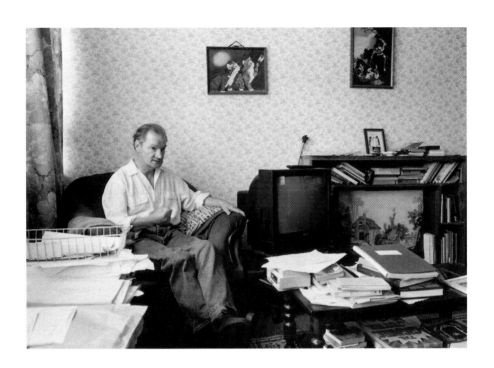

Whitechapel/New York

The performance artist presents himself as a member of the criminal classes. He is deranged by appointment, this elective Bedlamite. Shock-white, he poses on a darkened staircase. He has suffered the trance of travel. His *here* is infinitely adaptable, one city is any city. The particulars of photography are bent evidence. He can persuade you that sand is water, that London Bridge is to be found in the desert, somewhere outside Las Vegas. Don't believe what you see. Especially not the images with titles, specifics; the houses, streets, people he presents in his slide-show. They are actors, suborned citizens, authentic fakes. Madness too can be feigned, implicating unwary witnesses.

These freaks feed on ash from a dustbin lid. They swill pus. Mutes, in the grip of a self-induced nightmare, map out a journey: 'one inch to the hour'. Durational exercises have been devised to heal the mind of all its trash. The gaunt medium, his brain cooked to gruel, has nothing to work with but a catalogue of slides documenting an entirely fraudulent past.

Only when he is armed with a camera can the bachelor ascend to service his bride (why must she wear black?). The thing in her mouth is a pen, a torch. Distressed film stock has been shaped to curl a pubic beard. She sings of exile to keep herself from screaming an accusation: 'Rapist! Stealer of light!' She refuses the gossamer night-gown, backlit by neon: the black stain between her legs. She's an insomniac, not a sleepwalker.

Now attention is everything. In the cold hallway of the decommissioned synagogue in Princelet Street, spectral slide projections splash New York, the Lower East Side, onto the peeling stucco. Scratch away this alien city to reveal a phantom set of stone steps. Where else should David Rodinsky have disappeared? Apertures in the brick thin to India paper. A migrant mob, poets and women, file out of the ceremonial chamber. They take vodka against the clammy

night. The sky is as blue as the underside of a tongue. A hireling photographer, awkward in English, works the smoking machine. He photographs his rival, who abandoned these images when he crossed the Atlantic.

A taboo has been broken. Men in hats descend from the Ladies' Gallery. The senior witness, on the nod from the perfume of snuffed candles, keeps himself warm with a lap of retrieved sound. The wings of his heart beat against frozen air.

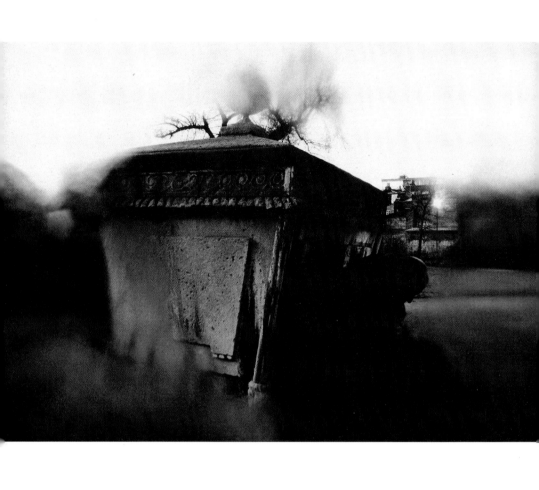

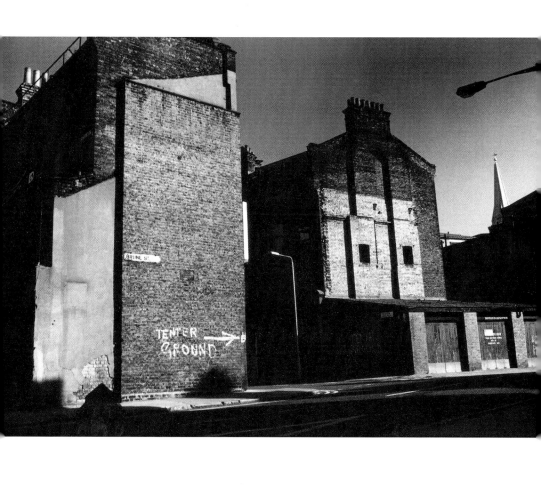

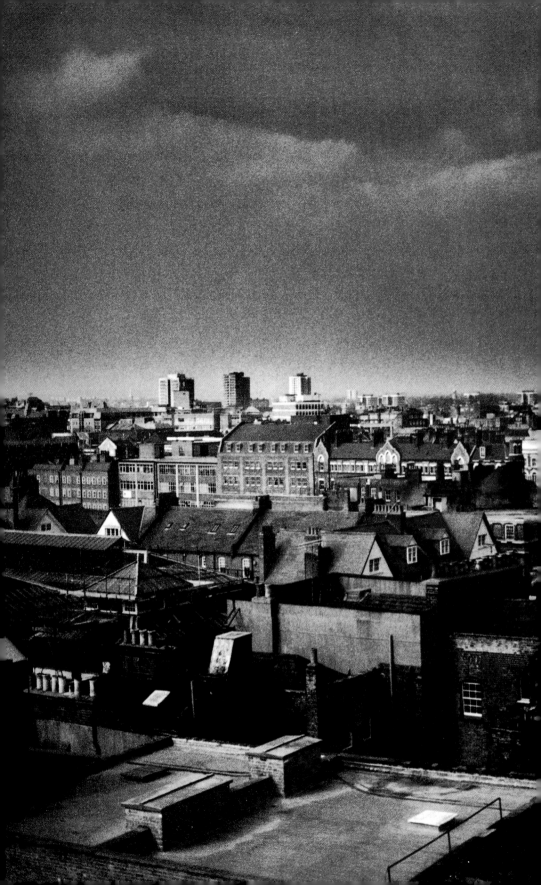

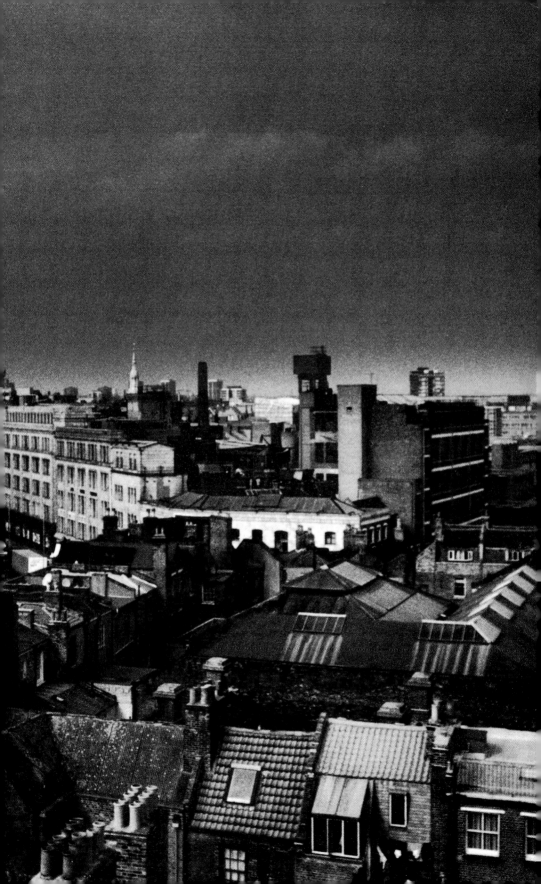

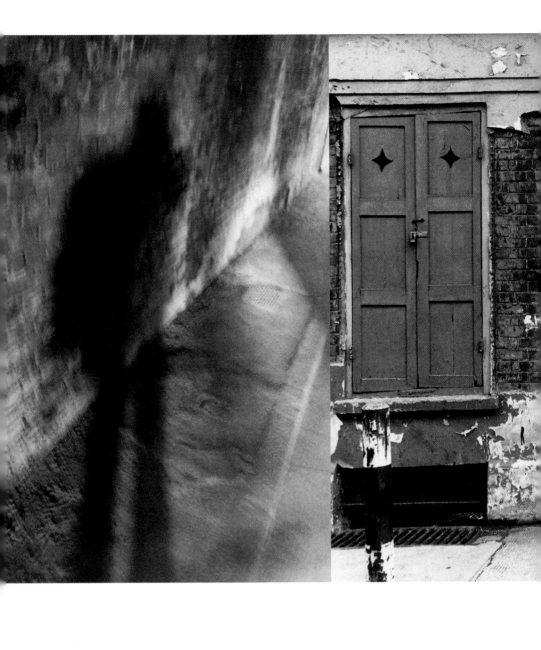

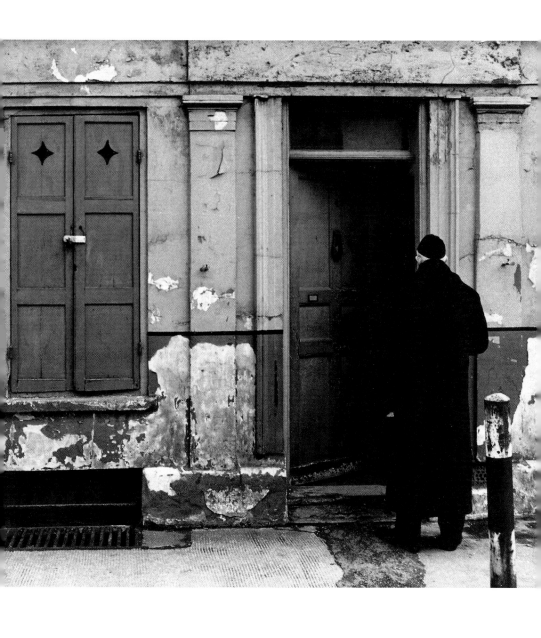

Tea with the plague warriors

Fournier Street. 22 February 1999

GILBERT: We are also very keen on big walks. Keen. At the moment I have a little problem – because I have flat feet. George walks to Hampstead. And back. In three hours. I did half.

INTERVIEWER: Do you go along the canal?

GEORGE: Main roads.

INTERVIEWER: For exercise?

GEORGE: To keep slim.

GILBERT: And for looking.

GEORGE: It's very soothing. For us. To see millions and millions of faces.

GILBERT: Crouch End. We take a bus up there and walk down. Very exciting.

GEORGE: And Streatham. It's the end of the bus route. We take a bus there and walk back. There's a restaurant we go to sometimes, a little bar. You can go from Liverpool Street on a 123 bus.

GILBERT: We don't go further east. Bethnal Green.

GEORGE: Not that far.

GILBERT: Hackney.

INTERVIEWER: When you're photographing bird shit do you start early?

GEORGE: Drift. We drift.

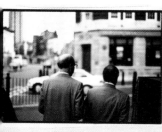
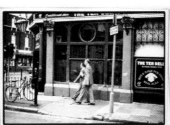
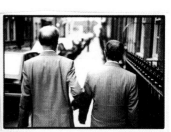
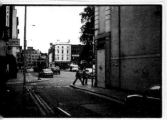
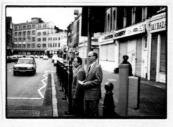

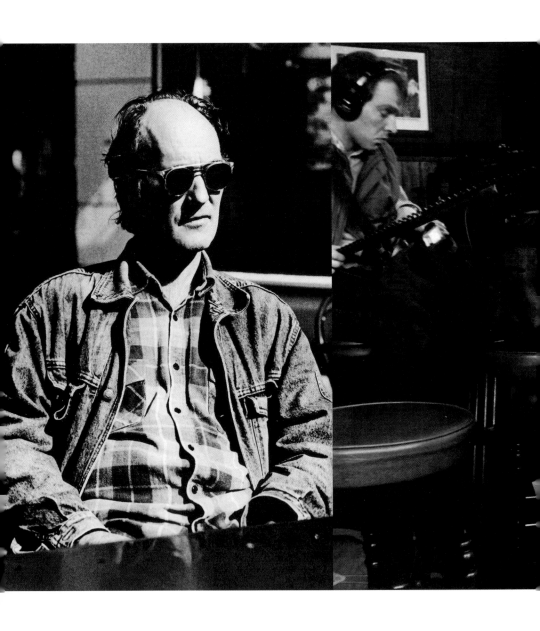

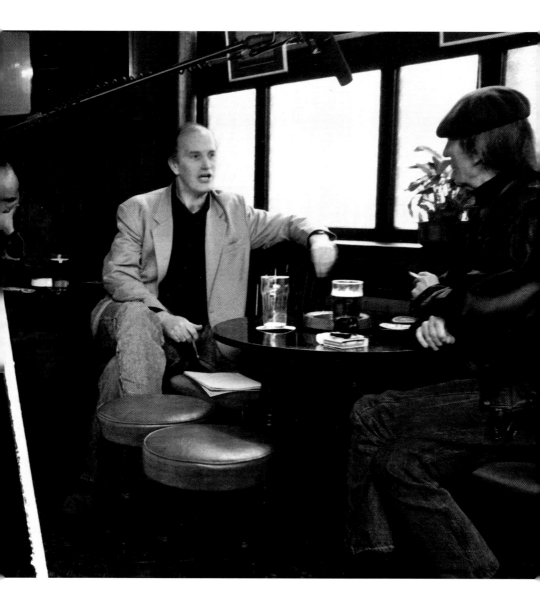

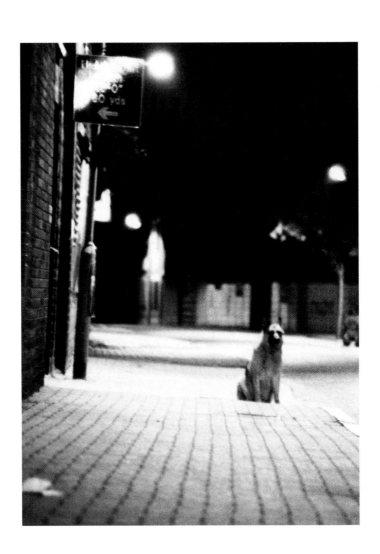

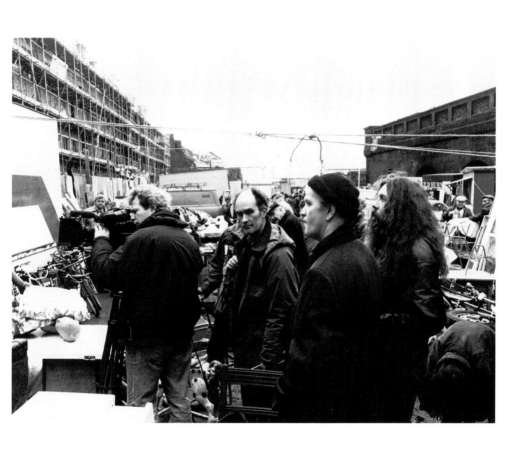

The Cardinal and the Corpse

The film was finished, and survivors gathered outside this pub, with its murky history, for the group shot. (Inside, Chris Petit had been trying, unsuccessfully, to pitch the story – discontinued literary careers, lost lives – to Lynn Barber. None of the other hacks had turned up. The event was off-piste. A ghost circus. Regulars, like Jock the piss-artist book dealer, didn't know what to make of this bunch who'd commandeered their TV for the night. But, as long as the complimentary drinks kept coming, what did they care?)

The line-up looks like a who's-next-for-the-grim-reaper? competition. Drif, in his white tux, is the MC, the mud-wrestling referee. Pat and Gerry Goldstein have taken charge of Robin Cook. Gerry, the scuffler, friend of David Litvinoff, appears the most affluent of the bunch. (He knows how to position himself against a nice white backdrop.) Alan Moore, in his heroically anachronistic schmutter, has a personal sunburst perched on his left shoulder. Catling seems to have swallowed his own lips (or sealed them with black wax). The flagstones are spattered with ancient stains. Marc's flash-gun highlights the pretensions of the mullioned windows and the ruched curtains that mask the interior from the eyes of the uninitiated. The night is inky. The Carpenters Arms (no nonsense about apostrophes) has detached itself from London and is floating across the glacial rim of deep space. A chorus of lightly fleshed skeletons take their bow.

In all such groups, there must be one unidentified figure, the messenger of fate. (If none are available, that role falls to the implicated photographer.) Petit, suited, fading into the brickwork, is the last man. Beyond him, drifting through the night, is the minder that nobody knows. The driver who drove the man who chauffeured the body of Jack the Hat under the river.

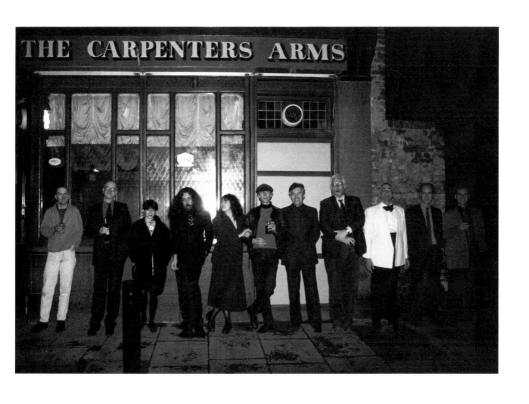

Conductors of chaos

I've always believed that bringing the best writers, the sharpest intelligences, to any location alters it forever. But risking 30 or so poets in a wine-bar in Spitalfields Market was pushing it. (The eviction orders were already in the post.) Then there was the title of the anthology they were celebrating: *Conductors of Chaos*.

It was the day that England played Spain in the European championships. The match was on the TV above the bar, and it went to extra time, a penalty shoot-out. (Nobody remembers the rare occasions when England win these things.) But the poets divided, quite neatly, between those ex-macho, pre-Hornby types who wanted to watch and the Cambridge Marxists who refused to acknowledge that it was happening. (They were horrified to find themselves cast adrift among trace elements of the unredeemed proletariat). We'd already lost the upstairs room (booked in advance), with its working sound system, private bar, to a local Mafia wedding. Drunken guests, barmen with their backs resolutely turned towards the football, peddlers from the market: they swilled and bitched. The mike was dead. Nobody could hear what was going on. 'Bad Boy' Charlie's mate was down from Birmingham and asking around, seeing if anyone had *anything* he could take: animal tranquillizers, expectorants, speed, worm pills. To wash away the flavour of these all-too-visible spectres with their mumbled or frantic agendas. Old quarrels were put on hold until later in the evening, when the party moved to the pub across the road.

What happened, happened at the margins. Off camera. Out of earshot. Stuff that should never be recorded. Secret monologues of the unacknowledged legislators. Prophetic fragments of poems left for an instant on blackboards, before being wiped out.

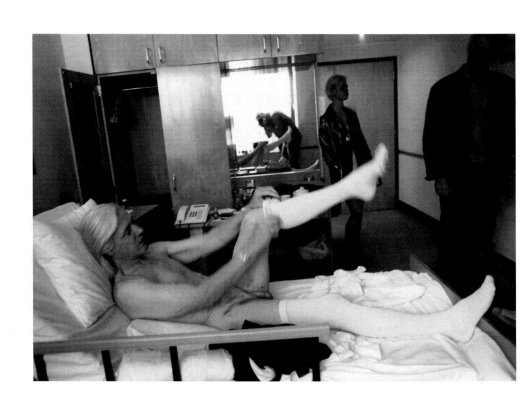

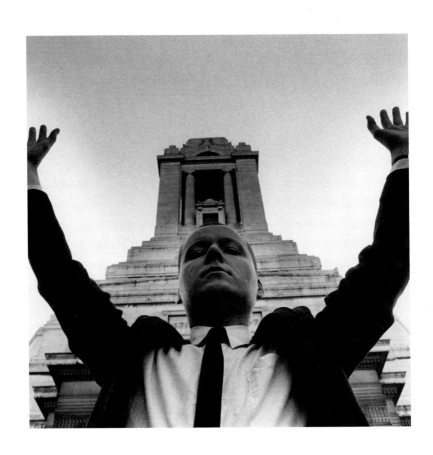

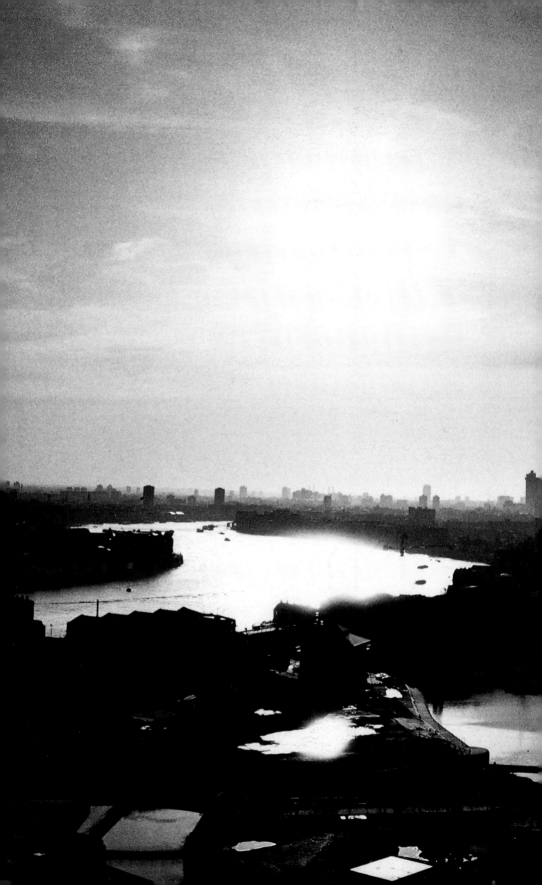

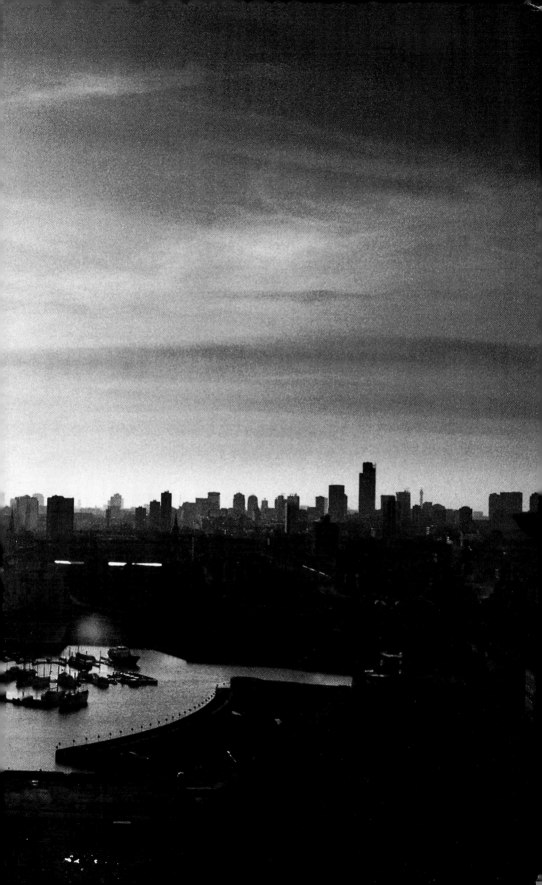

A provisional past

For those interested in such things, the history of my previous collaborations with Marc Atkins can be (mis)construed from this selective bibliography.

We met when he took a series of photographs during the making of a Channel 4 film, *The Cardinal and the Corpse* (see *Lights Out for the Territory* [Granta, 1997]). His portfolio began with location work in Cheshire Street market, moving on to a pink-doored Georgian house in Princelet Street, to subsequent portraits of members of the cast (Martin Stone, Alan Moore, Michael Moorcock, Robin Cook), to the end-of-shoot celebration at the Carpenters Arms. Some of these images were incorporated into the film. The usual trajectory was described: document to fiction to document.

Atkins's work, in the period when he had a studio on the east side of Brick Lane in Whitechapel, provided inspiration for the character of Imar O'Hagan (a Frankenstein's monster stitched together from many sources) in my novel *Radon Daughters* (Jonathan Cape, 1994). Atkins was responsible for the cover image and for images placed between the sections of the book. He also took part in the collaborative final chapter when three characters, who had appeared in the text in (light) fictional guise, spoke in their own voices. Atkins, attempting to capture, on the shortest day of the year, the spirit of the missing Whitechapel mound, pictured himself drifting around a sepulchral monument in the field where St Mary's church once stood. (There are many Atkins photographs that relate to a site I have returned to obsessively in my fiction: the gravestone of Helen Redpath, the drinking-fountain that looks like the Elephant Man's head, the skeletal brick outline of the lost church.)

I didn't know Atkins when I wrote *White Chappell, Scarlet Tracings* (Goldmark, 1987), but I took him back over the ground, in terror that it would disappear forever. I was never sure if he was logging a final record or initiating a permanent erasure. Photography carries a

heavy responsibility. Too many of the writers we visited would find an Atkins portrait decorating their obituary notices.

The *Downriver* (Paladin, 1991) sets were still fresh in my mind when I started doing London walks with Atkins in tow. He covered Tilbury, Gravesend, North Woolwich, Silvertown, the Isle of Dogs and all the rivers and railways. He dived into Gavin Jones's bunker, and he battled through the Rotherhithe Tunnel (see *Lights Out for the Territory*).

Often one of Atkins's photographs would trigger a future text. I'd forgotten about the print he calls *Rodinsky's Mirror*, but I guess it was there, lost in the lumber, when I put together my speculative essays for Rachel Lichtenstein's book *Rodinsky's Room* (Granta, 1998).

The shape of our collaboration achieves a nice symmetry with its most recent occasion, another film: *The Falconer*. We arrive at the point where we started: Atkins lurking at the edge of the set, watchful, ready to pounce. His classically dark prints used in the flow of the film's multi-channelled narrative as a way of stopping time. Here self-cannibalizing complexities reach their critical state. Atkins's *Radon Daughters* work, his photographic essay on Lord Archer's penthouse (from *Lights Out for the Territory*), becomes the starting-point for a short story that is given the treatment by artist Dave McKean (*Slow Chocolate Autopsy* [Phoenix House, 1997]). Book and film meet and mingle. Atkins is both a participant – one of the technical crew – and a fictional character. He is there in the hospital photographing a man who is so busy inflating his own mythology that he can't decide if he is a comic strip, an actor, a magician or a ratepayer who needs to sue for his continued existence.

This book is not, I hope, one of those strategic collaborations where well-behaved samples of text are found to dress up otherwise unpromotable landscapes. It never worked like that. The books don't need images, and the photographs don't need words. Often the prints are more fictional – richer and stranger – than the stories they never purported to illustrate. There is a world out there that isn't London and that belongs to no particular time or period. I look back on it, despite all the evidence to the contrary, as a collaboration that never happened. A series of accidents that occasionally fused discrete worlds.